BRUGUIÈRE
His Photographs and His Life

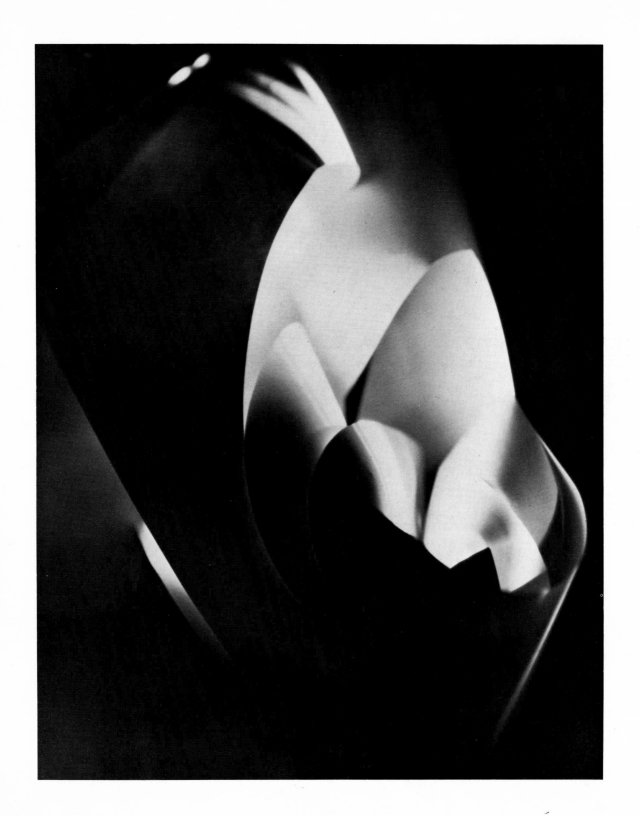

BRUGUIÈRE

His Photographs and His Life

Photographs by Francis Joseph Bruguière, 1879–1945
With a critical and biographical narrative by JAMES ENYEART

 ALFRED A. KNOPF NEW YORK 1977

THIS IS A BORZOI BOOK
PUBLISHED BY ALFRED A. KNOPF, INC.

Grateful acknowledgment is made to the following for permission to reprint
previously published material:
The Architectural Press Ltd.: "Light and Movement," reprinted from
 The Architectural Review.
Jovanna Ceccarelli, Publisher: Photograph of Thomas Wilfred's color organ and
 four images produced by this machine by Bruguière. Reprinted from pages 23, 24,
 and 25 of *Theatre Arts Magazine,* January 1922, vol. VI, no. 1, edited by
 Stark Young.
Gerald Duckworth and Company Ltd.: A photograph and excerpt from *Beyond
 This Point,* by Lance Sieveking and Francis Bruguière.
Harcourt Brace Jovanovich, Inc., and Routledge & Kegan Paul Ltd.: "Mandala
 no. 3" from *The Secret of the Golden Flower,* edited by Richard Wilhelm with a
 commentary by C. G. Jung.
Wistaria Hartmann Linton Collection at the University of California, Riverside:
 Excerpts from letters written by Bruguière to Sadakichi Hartmann.
Norman Parkinson and *The Tatler:* Photograph of Bruguière at the British
 Pavilion, 1937.
Henry Holmes Smith: Excerpts from *Creative Camera,* London, April 1976.

Library of Congress Cataloging in Publication Data
Enyeart, James.
 Bruguière, his photographs and his life.

 Bibliography: p.
 1. Bruguière, Francis. 2. Photography, Artistic.
3. Photographers—United States—Biography. I. Title.
TR140.B79E58 770'.92'4 [B] 77-75355
ISBN 0-394-40852-7

Manufactured in the United States of America
First Edition

For Roxanne and Rosalinde

Contents

Plates

Titles are followed by credits when required.

Acknowledgments

The author wishes to gratefully acknowledge the assistance of the following individuals: Rosalinde Fuller for her loan of Bruguière's notes and photographs and for her many interviews on his life and work; Oswell Blakeston for sharing his experiences with Bruguière; Lee Witkin for introducing the author to Ms. Fuller and for permission to reproduce several of Bruguière's photographs; Professor Mike Weaver for assistance in viewing the original *Light Rhythms* film at the British Film Institute; Mark Haworth-Booth for sharing his research on E. McKnight Kauffer; Dr. Stan Shumway for his masterful transcription of the original music score to *Light Rhythms*; Nina Howell Star for sharing her research on Bruguière; Peter Bunnell for his helpful suggestions and encouragement; Mrs. Pedar Bruguière for her interest and help; Francis Bruguière, Jr., for insights into his father and family history; Vicky Wilson and Ellen McNeilly for making the book possible; and special thanks to Anne Tucker, Bill Johnson, Sam Wagstaff, and Tom

Barrow, who contributed to the research with new information and enthusiasm.

In addition, the author is indebted to the following institutions: The National Endowment for the Arts for a Museum Professional Fellowship to research and write; the Royal Photographic Society of Great Britain for the use of their special collections library; the International Museum of Photography at George Eastman House for use of their photographic archive; and the numerous other institutions and individuals who gave their permission to reproduce works and articles from their holdings.

Most of all, special love and appreciation to Roxanne Enyeart, who offered constructive criticism on each stage of the manuscript and created an environment which made the writing of the book possible.

BRUGUIÈRE
His Photographs and His Life

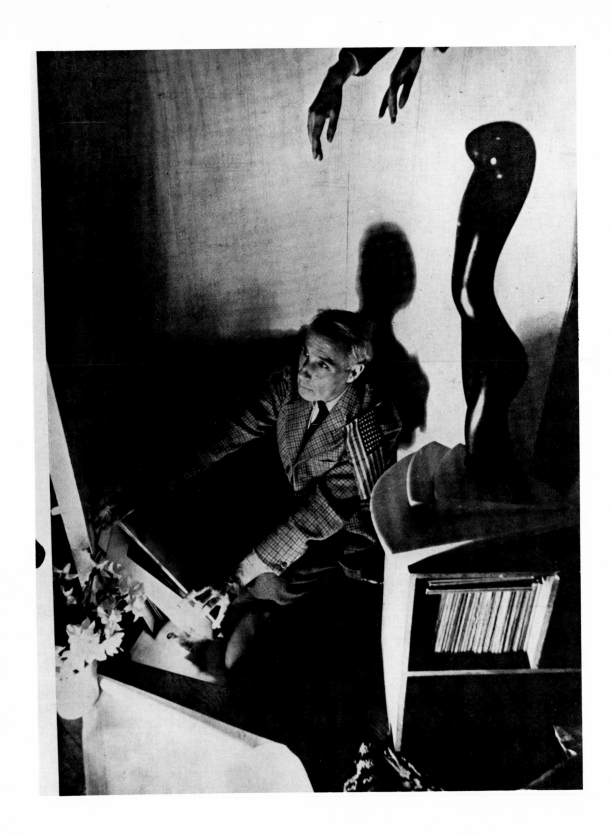

Bruguière at work in the British Pavilion, Paris, 1937

1

Early Influences
1900–1919

When the modern art movement began to expand, during the first quarter of this century, only a few photographers understood its potential and accepted the challenge for their medium. The Photo-Secession, created by Alfred Stieglitz, exemplified the spirit of avant-garde art, protesting the accepted idea of the photograph and its role in the art world. However, the *imagery* of most of the Secessionists remained tied to nineteenth-century pictorialism, and before the end of the second decade, the Photo-Secessionists, as a group, had disintegrated.

Its members were unable to fathom the quickening pace of Stieglitz's movement into the international art world. Works shown at "291" (one of Stieglitz's galleries) by Picasso, Rodin, Matisse, Cézanne, Brancusi, as well as primitive art and children's drawings, all had in common a fresh, direct approach to structure and freedom of form. But to most of the Secessionists, such liberty of expression was not an extension of their aesthetics. These ideas seemed outside the realm of photography.

Only a few photographers, such as Paul Strand, Edward Steichen, Alvin Langdon Coburn, and Francis Bruguière, continued to grow and to change their ideas about photography.

It was during this period that Francis J. Bruguière, painter, musician, and photographer, emerged as one of America's most individualistic photographers. Up to now he has been an enigma. Although his work has been published and included in major international exhibitions since 1910, general knowledge of Bruguière has been limited. Unlike Stieglitz and Edward Weston, he was not interested in, nor did he see himself in, a historical context. Stieglitz not only sought new visions in his own work, but through *Camera Work* (the quarterly magazine he edited and published between 1903 and 1917), he revolutionized the world's awareness of photography. His strict standards of exhibition and presentation and his clear aesthetic definitions cultivated in the critics, historians, and museums an understanding of the history of the medium. His aim was acceptance not just for himself, but for photography in general, which suggests a self-conscious attitude toward the importance of his aims.

Edward Weston kept his daybooks as a diary of personal and artistic self-assessment (though he wrote them with the flair of a novelist, for some future reader). Indeed, before he died he turned over his written work to Nancy Newhall as his biographer, a conscious effort to assure his place in history.

Although Bruguière became a member of the Photo-Secession, he was never one of the group. He preferred individual exchange. He exhibited with the Secessionists only once, at the Albright-Knox exhibition in Buffalo in 1910. After 1919, only a few persons saw and shared in his "experiments," until 1927, when he had a major one-man exhibition at the Art Center in New York. As his photographs, notes, and articles on the following pages will show, Bruguière was not driven by a desire to be part of history, but wished to be apart from it.

Among the reasons for the scarcity of information on Bruguière is the lack of investigation into the work of individual photographers. With the exception of the Newhalls, there have been few historians of photography who have *consistently* probed the nature of the medium and its users. Throughout most of the history of photography there have been works of self-publishing and general histories, but relatively few biographical studies with objective and carefully researched texts. Certainly the economic boom in collecting photographs today and academic acceptance has done much to reverse that trend.

It is a paradox that an artist like Bruguière could be so universally respected, yet so little be known about his life. Perhaps what contributed most to this was Bruguière's own personality. He maintained an indifferent attitude toward recognition and scorned the security of tradition and what he considered "bourgeois acceptance."[1] Cecil Beaton wrote of him in 1949:

> There was something so self-effacing about Mr. Bruguière himself that, during his lifetime, he was less acclaimed for the originality of his work than many of his disciples who achieved more notoriety than the master; and among those whom he encouraged and inspired at the beginning of their careers, I should like to include myself.
>
> When I first contemplated taking up photography, Bruguière showed me how simple the process could be and he also showed me how to take multiple exposures on one plate; this effect was one of the first to be acclaimed as startingly original when I held my first exhibition at Colling's Gallery [Cooling Galleries] in 1928.[2]

Bruguière's friends have described him as charming and quiet, yet openly disdainful of social and intellectual affectations. His reticence toward the establishment in both art and society reflected an attitude advocated by many painters and photographers who published articles in *Camera Work* between 1904 and 1912. Marius de Zayas (an avant-garde Spanish artist) attacked the art establishment when he wrote: "Our epoch is chaotic, neurotic, inconsequent, and out of equilibrium. Art is dead."[3] Sadakichi Hartmann, another prolific contributor to *Camera Work*, wrote an article titled "On the Vanity of Appreciation," which condemned recognition and public opinion as inessential ingredients in an artist's life.[4] In 1910 there appeared an unidentified article on "The Fight for Recognition," which used Manet as an example and extolled the artist for ignoring his critics, for not believing in or seeking public approval, but simply continuing his work, letting fortune and time be the final judges.[5] Recognition, public approval, and art with a capital *A* represented the establishment to Bruguière and to the authors of these articles. Their rejection of these things prepared the way for the next decade of avant-garde ideas. While it gave them a certain artistic freedom, it also brought a self-imposed anonymity.

In 1944, a year before his death, Bruguière began writing an autobiography, which included descriptions of his family and relatives as well as impressions of his childhood world. Bruguière's rejection of so-

cial status and its superficialities is certainly related to what he described as "the Empire Period atmosphere" of his home life, in a Victorian environment filled with steel engravings of Napoleon III and the Empress Eugénie, with an ever-growing library of "expensive bindings" and complete editions of Thackeray, Dickens, Eliot, Victor Hugo, Flaubert, Dumas, Balzac, and Shakespeare; and with an aura of "nostalgia" for both Napoleons by his father and grandfather, both of whom had attended school in France.

The autobiography was never finished beyond his recollection of the age of puberty, yet it reveals an assessment of the social attitudes that he grew to reject in adulthood. In a discussion of his parents' preoccupation with social status and family lineage, he wrote the following:

> These family myths perhaps have the power to sustain a mood and a kind of feeling that one is just a bit superior to one's neighbors. In the South especially there are many people who look back to their forebears as distinguished and important folks. I must say for my brothers and myself that such ideas of superiority had, when we were children, no apparent effect . . . for it was inhabited by the cream that rises above the watery milk, which sustains it by a physical law which always worried me in physics; that the heavier could be sustained so easily by the lighter and that the lighter so willingly accepted its role of remaining submerged in order to sustain it.

To Bruguière, tradition in either art or society was not to be trusted and was generally self-serving. As a result he avoided contact with the trends of the art world and society.[6]

For the first two decades of the century Bruguière was free from financial worries and was not really affected by the practical implications of his philosophy. By 1919, however, his situation had changed, but this philosophy had become an inextricable way of life for him. He continued to show his photographs only when asked and rarely shared his experiments with his peers, who were proceeding in different directions. The role of the modern artist was also changing and with the demise of the Photo-Secession, the period of artistic fraternity had evolved into an era of individualization and introspective expression. Additionally, whatever degree of recognition Bruguière may still have needed, he was more than satisfied by the acclaim he received for his professional work, both in San Francisco and in New York.

Francis J. Bruguière was born October 16, 1879, in San Francisco.[7] He was one of four sons in a wealthy banking family of French and Spanish heritage. His early adult years, prior to 1900, were spent in a private boarding school in the East, where he gained an appreciation for music, painting, and poetry. Also during this period he toured Europe with his parents, deepening his interest in the arts.[8] In 1917 he contracted tuberculosis, and although he recovered, his respiratory system remained susceptible to bronchial infections, a weakness that contributed to his death from pneumonia in London in 1945, when he was sixty-five.

In his unfinished autobiography Bruguière wrote of an incident in his early childhood:

> On the day I was baptized, I think my brother Emile was baptized at the same time. The ceremony took place at St. Mathews church, San Mateo. I was naughty when I returned home, and was shut up in the closet. The baptism, as I then understood it, as it was explained to me, was a magical thing and was going to make me good forever. It was a terrible shock to me when immediately after, I was punished. I remember crying bitterly in the darkness and wondering if God would punish me for my all too soon sin.

In his later years, Bruguière, as a mature artist, probed the manifestations of deity out of an impulse that no doubt derived from this experience. His multiple exposures and his abstract images utilized the psychology of C. G. Jung and Eastern philosophies as reinforcement for his tenuous religious beliefs. The abstract and surreal qualities of his images paralleled the intangible tenets of Jung's studies of man's inner experience and the Chinese Taoist's use of meditation as a divine (psychic) experience.

Bruguière's experiments with abstract photographs in the twenties broke all the rules, in a further reflection of the personality revealed in his recounting of childhood experiences. After carefully describing the house he grew up in, room by room, he wrote:

> By the back stairs was a step ladder which led to the space below the roof where the water tank was. We used to surreptitiously climb up in this dark space and crawl over the rafters that held the lath and plaster of the ceilings of the rooms below. As we were forbidden to do this we derived pleasure and excitement in breaking the rule. It was a kind of mysterious adventure and something to be whispered of between ourselves, when we were trying to think of something out of the ordinary to do.

This experience had taught him to be unafraid of the unknown, an attitude apparent in the abstract works of his maturity. As an adult, he was excited by doing something out of the ordinary and different; he was uninhibited in his approach to art and society alike.

In 1901 Bruguière married Eliza Jones, a young Broadway actress who was on tour in San Francisco. In 1904 Francis Bruguière, Jr., was born and in 1905 Bruguière made an extended visit to New York, where he met Alfred Stieglitz and Frank Eugene Smith (better known as Frank Eugene). For the better part of a year, Bruguière and Eugene exchanged ideas, which resulted in Bruguière's decision to investigate photography as an art form. Their relationship was not one of student and teacher, as reported in previous articles on Bruguière. Rather, it was a period of inquiry for Bruguière which was inspired and influenced by Eugene. The two became close friends and remained in contact the rest of their lives.[9]

Eugene's influences on Bruguière involved an initial technical mastery of the photographic process and an indoctrination into the soft-focus, romantic style typical of Eugene himself. The tondo portrait of Eugene in Plate 1 and the Panama-Pacific Exposition of 1915 in Plate 2 show Bruguière's assimilation of those influences. Plates 3 through 6 reveal his rather common approach to allegorical subject matter typical of numerous salon pictorialists of the period.

At first Bruguière was content with a rather dogmatic approach to photography and reserved intuitive experimentation for his painting. Even then, and for a later period in San Francisco, photography was a second choice:

> Photography remained for certain sunny days when my other experiments palled, and a new idea for light and shade, an idea which could best be preserved by camera and lens occurred to me.[10]

Bruguière's visit to New York turned out to be a major turning point in his life and work. It was there that he met Alfred Stieglitz and became a member of the Photo-Secession; it was there that he acquired the inspiring and loyal friendship of Eugene (and later Sadakichi Hartmann and Baron de Meyer) and met such men as John Burroughs, the poet and naturalist, and the painter Albert P. Ryder. Bruguière first imitated Ryder's style in his own painting. No doubt Ryder's eccentric techniques further prepared Bruguière for his own freedom from conventional photographic thought.[11]

Alfred Stieglitz and "291" played an even more liberating role.

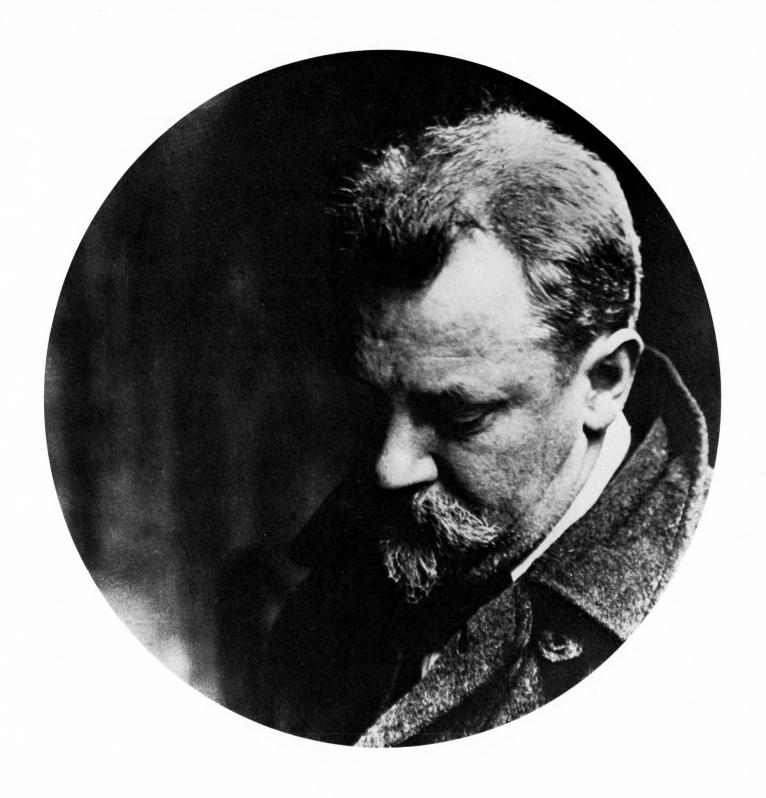

1 Frank Eugene, 1905

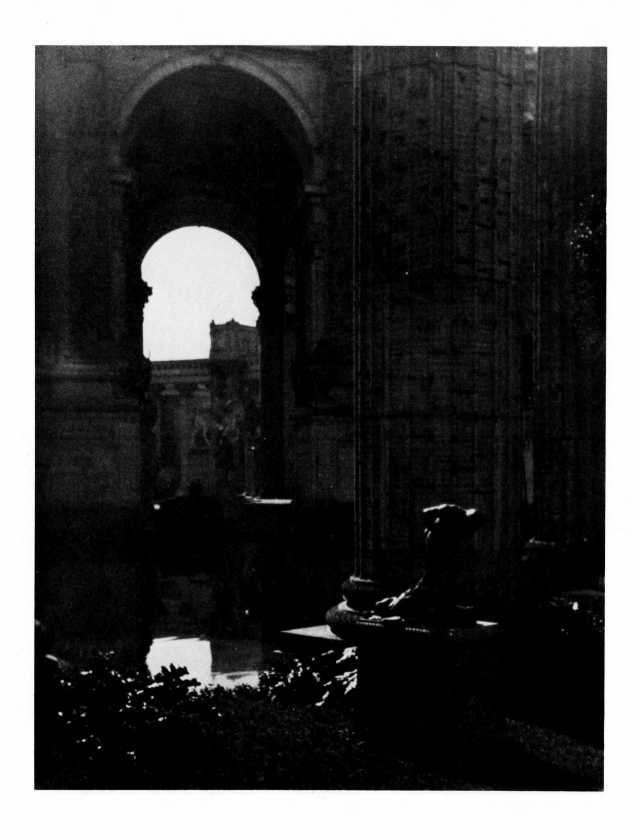

2 Panama–Pacific Exposition, 1915

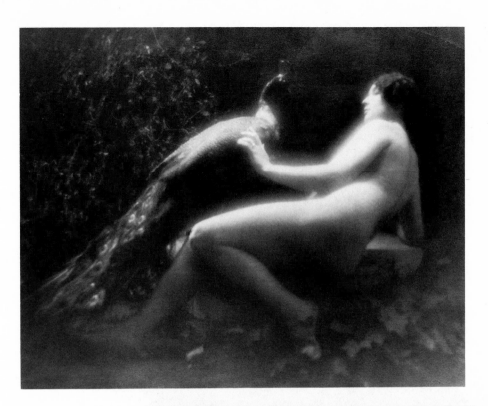

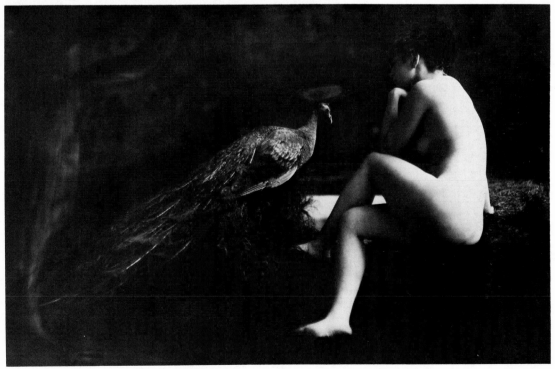

3 "Juno," c. 1915
4 "Vanity," c. 1915

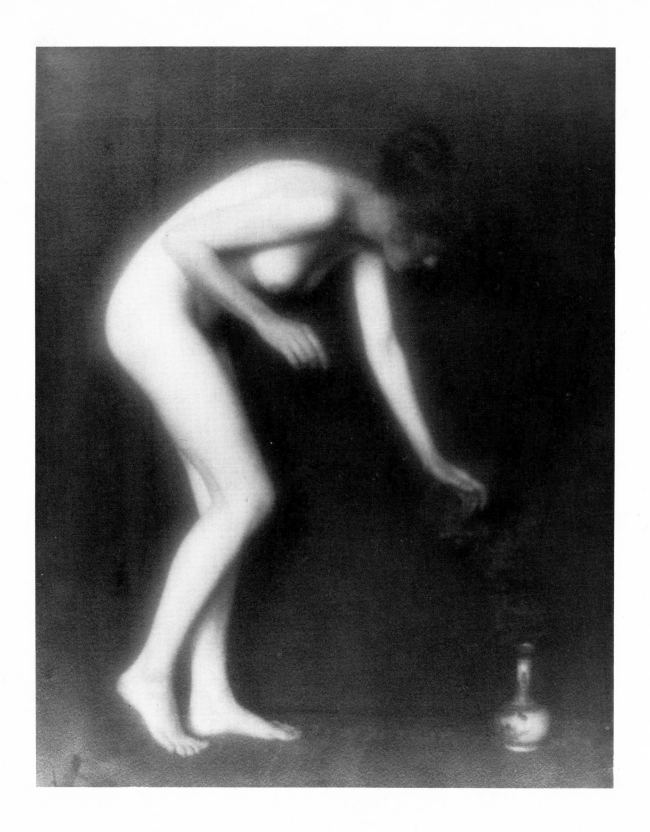

5 "Juniper," c. 1915

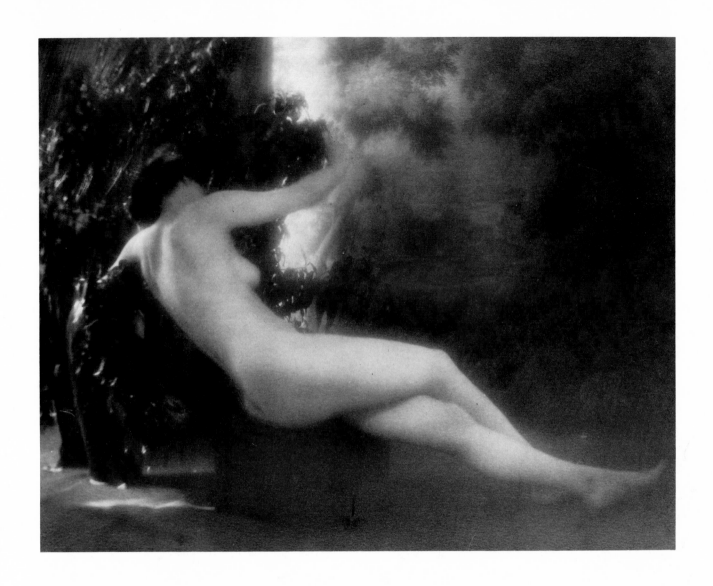

6 "Daphne," c. 1915

Some years later, Bruguière wrote "What *291* Means to Me," for publication in *Camera Work:*

> It is the most helpful place to be in for anyone whose mind is open to suggestion. There is no feeling of smallness there. Frank, honest criticism of a constructive kind always! No subject too small to be ignored, no idea is too great to find response. All kinds of people go and come. If you go there often enough you will find just how big or small you are. Sometimes the awakening comes as a shock. But after all it is an oasis in the desert of American ideas.[12]

Eugene acquainted Bruguière with the Photo-Secession and *Camera Work* in 1905, and for the next fifteen years Bruguière developed a strong sense of synthesis and inquiry into the potential of the photograph. He questioned the contribution of sentimental and romantic photographs and developed his own methods of experimentation. As art in other media became more abstract, Bruguière weighed the potential for the photograph to achieve the same ends. Stieglitz's *Camera Work* presented contrasting ideas which helped Bruguière in the experimental photographs that mark his career after 1920.

In 1905 Charles Caffin wrote an article for *Camera Work* (No. 12) on the Taoist-Buddhist philosophy in Japanese art, titled "Of Verities and Illusions." In it, Western art is pitted against Eastern; the material against the spiritual; reality against the soul; and the means or individual against the end or universal. The article is an excellent synthesis and chronology of the two art worlds, touching upon elements which became the core of Bruguière's imagery after 1919—a use of form, time, space, and inner awareness as the formal aesthetic concerns of his abstractions.

Five years after Caffin's article appeared, *Camera Work* (No. 31) published an essay by Max Weber on "The Fourth Dimension from a Plastic Point of View." Weber established his thesis of the fourth dimension as "consciousness of a great and overwhelming sense of space-magnitude in all directions at one time . . . somewhat similar to color and depth in musical sounds." Although Weber's article was cubist in its intent, it reflected a psychological attitude toward art which had already impressed Bruguière. A decade later Bruguière used the kinds of ideas presented by Caffin and Weber to create his light abstractions, which he referred to as "the fourth dimension . . . that is the effect I have long wanted to give."

Camera Work also inspired various projects which Bruguière devel-

oped years after the journal was published and he had stopped making light abstractions. Alvin Langdon Coburn's article on "The Relation of Time to Art" appeared in *Camera Work* in 1911. The essay concerned the role "time plays in the art of the camera," specifically in relation to Coburn's vision of New York and its skyscrapers. Two decades later, in 1932, Bruguière made a series of images on the skyscrapers of New York.

The importance of the *Camera Work* years to Bruguière, and to all American photographers of the twenties and thirties, cannot be overestimated. It was in that publication that they saw, read, and experienced the formative ideas that subsequently dominated so much of avant-garde art. It was there that they saw in perspective their own medium as it related to the rest of the art world.

Following the great San Francisco earthquake and fire of 1906, Bruguière opened a photographic studio on Franklin Street; he later moved to Post Street. He continued his interest in music and painting, but in the words of Stieglitz, he had become an "enthusiastic practitioner of photography."[13] In 1910 four of his photographs were included in the International Photo-Secession Exhibition at the Albright-Knox Art Gallery in Buffalo, New York.[14] Finally, in 1916, *Camera Work* published one of his photographs (Plate 7) along with the work of Paul Strand, Frank Eugene, and Arthur Allen Lewis.[15]

In 1912–1913 Bruguière made a tour of Europe and Greece. The photographs from this trip reflect his own struggle with traditional pictorial imagery and the new "straight" photography of Stieglitz and Strand, which had one foot in abstraction and the other in photographic exactitude. Pictorial photographs during this period were romantic idealizations of the world and were achieved by a variety of hand manipulation methods. The straight photographic approach advocated nonmanipulation and promoted the intrinsic qualities of the photograph (sharp focus, extreme detail, wide tonal range, and contact printing rather than enlargement) as the basis for aesthetic concern. In addition, the straight photograph introduced a greater emphasis on form for its own sake. One image of Bruguière's from this series (Plate 8) is reminiscent of Stieglitz's landmark equivalent, *The Steerage*.

As early as 1912, Bruguière had begun to feel the pull of the "modernist" aesthetic and developed his own experiments with photography.[16] Using a unique system of multiple exposure, which incorporated various individual images on a single plate, he explored the

psychological impact of seemingly irrational or "unreal" imagery.

It is also worth noting that in the same issue of *Camera Work* that published Bruguière's photograph, Stieglitz announced a new publication:

> During 1915–16, amongst other experiments, was a series with type-setting and printing. . . . The outcome of those American experiments has been a portfolio, consisting of twelve numbers of a publication called "291." . . . The new typography has already a name: "Psychotype," an art which consists in making the typographical characters participate in the expression of the thoughts and in the painting of the states of the soul, no more as conventional symbols but as signs having a significance in themselves.[17]

This introduction to *291* reflects the psychological nature of the avant-garde "isms" in modern American painting which were influencing Stieglitz and photography. Phrases like "expression of the thoughts," "painting of the states of the soul," and "signs having a significance in themselves" could easily describe Bruguière's photographs after 1920.

From 1905 to 1919 a number of artists, such as A. L. Coburn, Stieglitz, Paul Strand, and the "291" painters (Marius de Zayas, John Marin, etc.), were moving toward a common commitment to experimentation and a philosophical resolve toward abstraction. Like the work of Bruguière, Coburn's gravures, before 1910, were extremely pictorial, yet their geometric compositions hinted at an interest in abstraction. In the same year that Bruguière began his experiments, Coburn created his first virtual abstraction, *The Octopus*, and by 1917 Coburn had developed his totally abstract "Vortographs." In 1916, four years after Bruguière, Coburn also experimented with multiple exposure in a cubist-like portrait of Ezra Pound. In that same year Coburn wrote an article for *Photograms of the Year* on "The Future of Photography." When reviewing an exhibition of American work at the Royal Photographic Society in 1915, Coburn referred to the photographs as "groups of various objects photographed because of their shape and color value, and with no thought of their sentimental associations, most of which bore the title design." In apparent deference to the meaning that had been established for the title, Bruguière thereafter referred to his own abstractions as "designs in abstract forms of light."

An aesthetic based on abstraction, common to Bruguière, Stieglitz,

7 *Camera Work* gravure, 1916

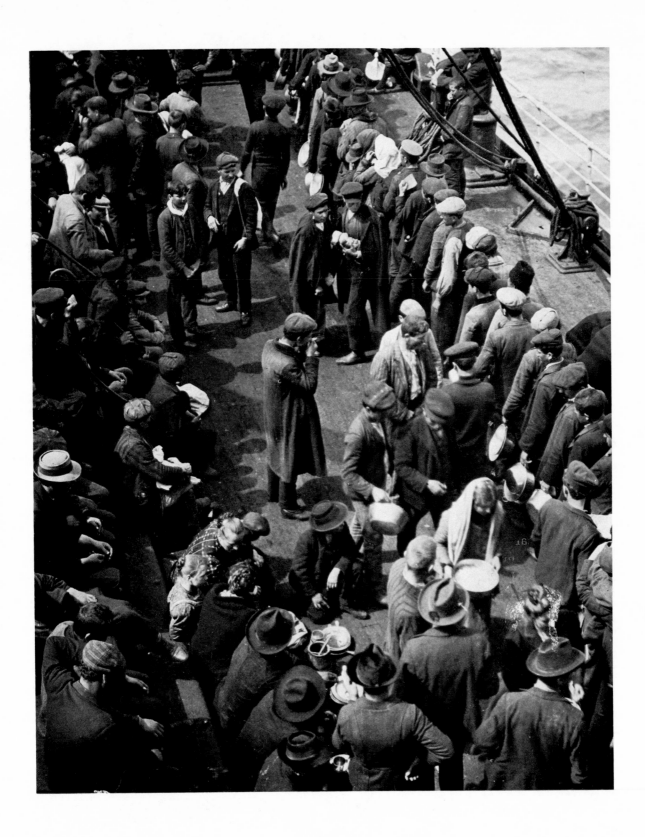

8 Soup line on freighter, c. 1912

Coburn, De Zayas, and others, produced in them a desire to manifest a sense of reality which they considered beyond nature itself. In 1912 J. N. Laurvik reviewed for *Camera Work* (No. 39) "The Watercolors of John Marin," in which he expressed the essence of an aesthetic based on abstraction: ". . . form has been most knowingly summarized, producing the *effect* rather than the *appearance* of reality."

Marius de Zayas's drawing of Alfred Stieglitz (*Camera Work*, No. 46, 1914), is another example of this same concept. It is a composition of geometric shapes and mathematical equations which represented "the spirit of man by algebraic formulae, his material self by geometric equivalents, and his initial force by trajectories."

However, more closely related to Bruguière's interests (seen in his work after 1920) was a statement by Paul Strand from an article in 1917 for *Seven Arts* ("Photography," *Camera Work*, No. 49/50), which specifically related abstraction to the emotions: ". . . the objects may be organized to express causes of which they are the effects, or they may be used as abstract forms to create an emotion unrelated to the objectivity as such."

Although Bruguière's and Edward Steichen's personalities were completely different, their careers had many similarities. Steichen, like Bruguière, began as a Secessionist, making romantic, pictorial imagery, but by the twenties he had devised his own methods of abstraction. Also during this period, he, like Bruguière, was a professional photographer for *Vogue* and *Harper's Bazaar*. Both men drew upon their personal imagery and ideologies in their commercial work. In 1932 both photographers made a series of multiple exposures of New York City, and the choice of an identical upward camera angle and the similarity of final images suggests an unusually close aesthetic preference. Both men had been painters, and had an awareness of the rest of the art world. As a result, neither was ever content with a single process or approach to photography, and throughout their respective careers each accomplished a wide range of technical variation in his work.

In 1918 Bruguière published a book of photographs on San Francisco. The images were typical of his early Secessionist work and revealed little of the intellectual revolution embodied in his experiments. The book did have a unique feature, however, in that the photographs were linked together by an original text in free prose—a format that, years later, he exploited in greater depth and significance in a book titled *Beyond This Point*. Oswell Blakeston, author, poet, and journalist, met Bruguière in 1929. In a 1949 article for *Picture Post* on Bruguière's

photographs, Blakeston noted that the book became a catalyst for Bruguière, causing him to reevaluate his use of the camera:

> Isolated between the covers of a book, the pictures looked lamentable. They were, like all "artistic" photographs of the period, imitations of aspects of painting. Bruguière shuddered and he knew that never again could he pretend the camera is anything but a machine.[18]

Inspired by a heightened self-consciousness toward his photographs as well as the earlier collapse of his family's fortunes (the San Francisco earthquake destroyed the family business and his mother died on the S.S. *Arabic* in 1916), Bruguière moved his family to New York in November 1918. For the first time, he was forced to rely on photography as his primary means of support. He opened a studio at 16 West 49th Street and within a year had gained a reputation for his work in *Vogue*, *Harper's Bazaar*, and *Vanity Fair*, and for Theatre Guild productions.

2

New York
1919–1927

Between the years 1919 and 1927, Bruguière devoted more time and energy than ever before to experiments, based on a desire to free photography and himself from the "external" world.[19] He approached his professional work with the same sense of conviction and creative challenge that he brought to his own photographs. As a result, even though his commercial obligations were extremely time-consuming, the methods he used contributed indirectly to the experiments he carried out at night in his studio. He continued to refine his multiple-exposure technique and from his Theatre Guild work he was gaining a new appreciation for light.

By 1923 two forceful styles had emerged as a result of Bruguière's nightly experiments: from the multiple-exposure technique came a series of surreal images making up a still-photo scenario for a film he hoped to produce, to be called *The Way*; and from his growing obsession with light as the quintessence of the photo image he developed a style

and method of "light abstractions" that were as unique as the photograms of Man Ray and Moholy-Nagy.

Bruguière would often write down, at length, his ideas or impressions. These bits and pieces of paper were for his benefit alone. They were structurally and grammatically unfinished, but they reveal his concern for photography as an art form. One set of notes, dated May 1924, carefully analyzes the individuals and works around him:

Everyone should be concerned with the difference between good and bad photography. The ignorance of the public regarding a medium that is in everyone's hands, / The ease of making a photo, the difficulty of making a good one. The value of a school such as this / the standardization of photo by commercial photographers / the hindrance of its recognition as a medium of individual expression / its slow recognition as an art. Its growth through the work of amateurs / the desire of experimenting to make it look like painting through different processes. Could plates be sensitized so intermediate tones could be eliminated and broader effects be obtained, such as shadows thrown on paper by objects placed in contact with it. The realization that comes by direct practice more difficult to accomplish than making effects in bromoil or gum.

Frank Eugene originally a painter dissatisfied by what the camera gives / his desire to scratch plates perhaps to give it more personality / his true talent as portrait photographer / charms the sitter into semblance of a human being when sitter could respond to his personality / perhaps best portraits are those where there are repeated sittings. Is it [It is] possible to get a portrait that does not appeal. / better send them to another whom you think could get result. Types respond to similar types / an artist working chooses his subjects / difficult to please the general public except with work similar to samples shown / a matter of selling organization working for publications necessary to meet their standards which are reactions to public demands.

moving pictures, largest field of photography, only in a few instances to be compared to the best still photographs / again standardization of products affecting quality / experience with Dance Macabre / relation of stage photography to moving picture.

Stieglitz foremost photographic worker / only let his best work go out / his endeavour shown in small prints in Flat Iron building and

Winter on Fifth Avenue, same spirit in his latest works on the sky.

What we desire in youth given to us in middle age / music of Wagner / Stieglitz realizes the picture exists everywhere / it is what you can do with the subject, how much does it enter

into you / your reaction / what will your medium let you get out of it, do you know what you want to do / that will be done plus your technique and your conviction / no tradition to fall back on in photography, the youngest of the arts / Delaroche said when he saw first daguerreotype painting was doomed / prophecy fulfilled for the kind of painting that resembles photography / on the wane / expression of modern painting less and less realistic / no great painting depended on realism for its message / the camera makes a compromise with nature / ignorant people say a photo cannot lie.

Curious thing happens in intelligently taken photographs / really gives you what you see / what you take, the reflection of your own vision / that quality of mind should be cultivated / the thing you see inwardly, emotion / desire to express feeling, thought, mental reaction / reflected in the work of a photographer.

Ultimately what is the destiny of this means of expression that deals with light / electricity has made effects possible that could not be done without elaborate systems of mirrors and reflectors / electric mobility / filaments of lamps can be projected in remarkable shapes / patterns of light can be conceived by the photographer / their part in his composition / possibility of movement of light in motion pictures in relation to treatment of drama / The opposition of light through scenes of a picture could be made effective / same idea could be applied to carrying out series of still pictures / the Divine Comedy in which this was done.

At present best photography in the movies not averaging near the work of twenty years ago in still photography / Back lighting discovered in the movies six years ago / four years ago soft focus lenses and gauze discovered / things move slowly / that so still a large field before the photographer / only in the beginning / will develop / takes its place.

Should be examples of best work in museums, so public could see and be able to have standard of what is good work / Public knowledge dependent on the kind of photos seen in showcases / in its way

just as important as painting, more important to general public because is within their means.

The content of these notes reveals Bruguière's contemporary thoughts on photography as well as ideas that were germane to his work after 1924.

When Bruguière condemns the "standardization of products" as a hindrance, he is referring to those commercial photographers who systematized their work. From the very beginning of the history of photography there have been individuals whose motive in making portraits was more financial gain than self-expression. Their method of working has always been the same: standardization of the setting, standardization of the process, and, of course, standardization of the end product. Bruguière thought the works of these *technicians* were more well known among the public than the work of artists like Stieglitz and himself. He notes, therefore, the urgent need for museums to collect photography in order for the public to have a standard for measuring good work. Just as Stieglitz preferred to consider himself an amateur rather than a professional, Bruguière objected to being labeled a commercial photographer.

The "equivalent" theory was an integral part of Bruguière's philosophy, which he also referred to in his notes: ". . . the picture exists everywhere . . . how much does it enter into you, your reaction . . . the thing you see inwardly, emotion, desire to express feeling, thought, mental reaction." An equivalent was more than a philosophy of life, it was a means of visualizing his emotions. The photographs for *The Way* were, in this respect, as much equivalents as his light abstractions.

The majority of Bruguière's commercial work consisted in photographing theatre performers and in recording, with unequaled precision and effect, the stage designs and models of New York's leading theatre producer-designers. His portraits were generally conventional, except for a strong sense of animation, inspired by his Secessionist years. The most interesting aspect of Bruguière's commercial portraits was his treatment of the backgrounds. In order to harmonize the spatial relationships of the background with those created by the sitter, he would shape the negative areas of the photograph with light and shadow, use patterned materials or paint large abstract backdrops. The painted backdrops often echoed his own painting, which closely resembled the works of the Synchromist movement (Plate 9). In regard to these portraits, Bruguière wrote:

I take portraits of people, and when I take them to please the sitter I place the third eye of my camera on their plane of consciousness. Perhaps you may think this sounds arrogant. It is not—it is simply that I am so wholly in sympathy with their point of view that I would not dare to give them something which they did not want. Sometimes I find persons who, though they do not understand just what I am aiming for, are yet willing to experiment and will lend their time and energy to me.[20]

Among those who were open to his experiments and consequently inspired some of his best portraits were Ruth St. Denis, Angna Enters, and a young Broadway actress from England, Rosalinde Fuller (Plate 10). She was sent to Bruguière in 1922 by *Harper's Bazaar* for her portrait as Ophelia, and became his confidante, amorist, and model, remaining with him until his death.

Bruguière was an official photographer for the Theatre Guild between 1919 and 1927. He produced a body of work that gave the Guild "a living and exciting photographic gallery, and saved their many interesting productions from the usual obliteration of the final curtain."[21] Among those whose stage productions he most often recorded were Robert Edmond Jones, Lee Simonson, and Norman Bel Geddes (Plate 11). Although these stage designers could conceive their productions through paintings, scale models, and drawing-board techniques, two problems still plagued them: how to provide an accurate preview of the entire set that would convey their intentions to others; and how to record the actual production. Using innovative lighting methods and techniques borrowed from his multiple-exposure experiments, Bruguière was able to translate what he intuitively felt were the designer's original intentions. His photographs of their models and sets so moved the designers that they heralded him as their interpreter and critic.[22]

Many of the photographs that I have made in New York theatres were made under the direction of designers, and generally the light on the stage was readjusted by them to what had been their original intention. I, in turn, readjusted this lighting to make it possible to record it photographically. Thus the photographs that have been made of these productions show more of the intention of the designers than is seen by the public who go to the theatres.

The readjustments that I make in the stage lighting when I photograph a set are to compensate for the differences between the vision of the human eye and the vision of the lens, plate and paper.

. . . The adjustment is made by taking into consideration the speed at which the different colors travel photographically. Blue, green, yellow and red are the principal colors that have to be considered. These colors as a rule are controlled independently on the switchboard of the modern theatre. To obtain results it is necessary to allow the blue to be exposed for a shorter time than the green, the yellow, or the red. Before taking a photograph I study the set to see the color relations. With the electrician I then work out a scheme for cutting out at certain specified points—the camera remaining open all the while. For instance, I might tell him (depending on the intensity of the colors) to shut off the blue light at the count of five, the green at ten, the yellow at twenty, and the red at thirty. In this way the camera will achieve a relation of tone approximating the relation of color in a set.[23]

Bruguière's technique of recording different forms with varied illumination at separate moments in time was basic to his multiple exposures, his light abstractions, and his theatre work. Although technically related, the three endeavors were stylistically different and manifested separate levels of concern by Bruguière for photography as an art form. The theatre works are important because they give the illusion of the actual or "real" in a purely photographic way. The multiple exposures are surreal dramatizations of the emotional states of man and reveal an attempt to portray an inner reality. The light abstractions are intellectual symbols for the psychological realm that exists beyond normal consciousness.

In about 1923, Bruguière met a young German dancer, Sebastian Droste, whose dramatic personality and fanciful contact with reality (he called himself "Baron Droste" and gate-crashed the core of New York society) inspired Bruguière to create one of his most important works (Plate 12). Droste and Rosalinde Fuller became the sole actors, posing for the still photographs, in Bruguière's fantastic, surreal film *The Way*. Unfortunately, Droste died of a brain hemorrhage in 1925 and the film was never finished. Nevertheless, the photographs made during those two years were exciting in themselves and today survive as one of the earliest surreal works by an American photographer.

According to Bruguière, the scenario for *The Way* concerned various psychic states, and the episodes represented were:

. . . thoughts of people who imagine rather than act realities. The

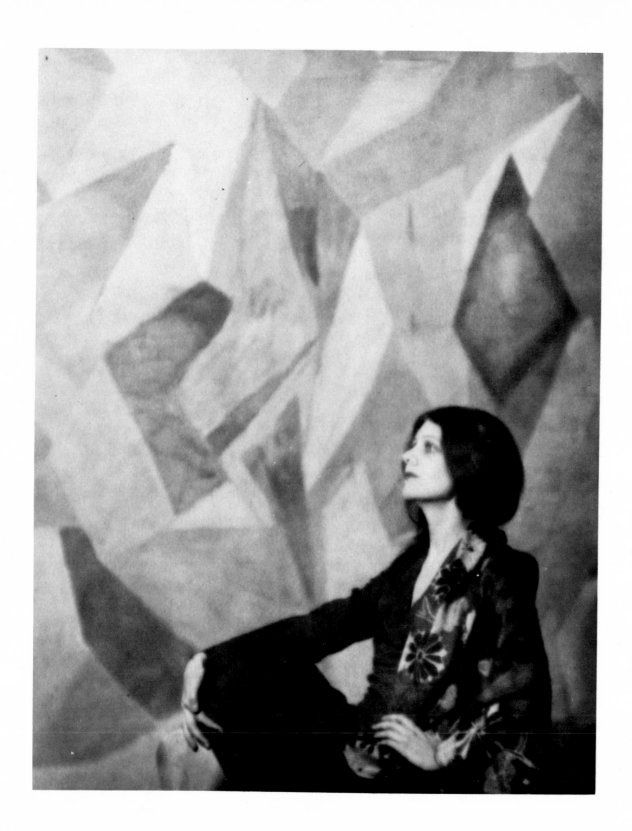

9 "Experiment," c. 1925–26

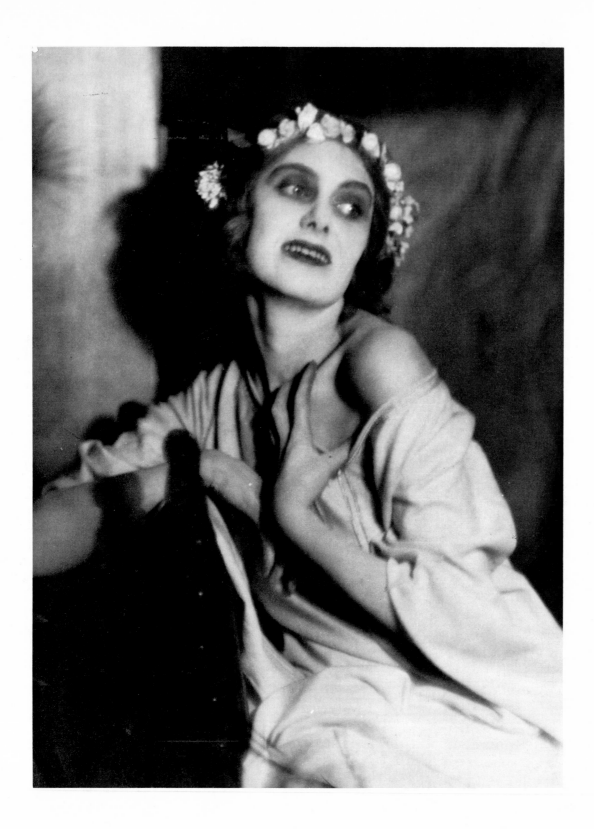

10 "Ophelia," 1922

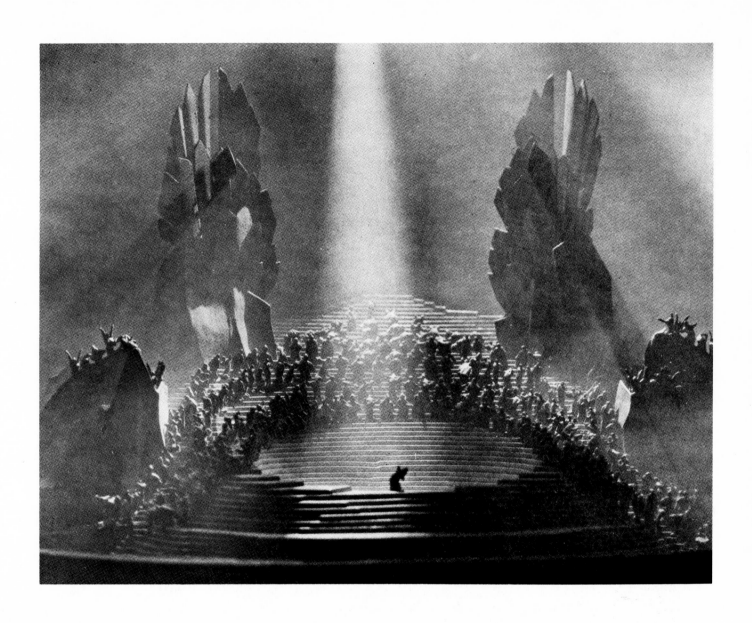

11 Photograph of stage model for *The Divine Comedy*, c. 1924

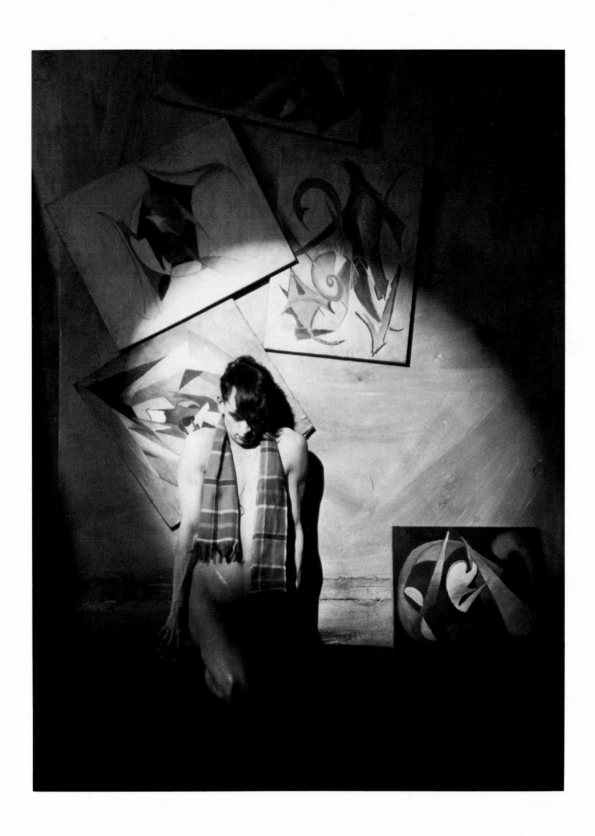

12 From *The Way*, 1923–25

main idea is that of a man who seeks happiness. From the beginning of his pilgrimage to the end, he lives in a world of dreams. He seeks his goal through the love of woman, the vice of drugs, as a clown in a circus, as an Egyptian dancer, through the power of empire, and the ideas of a religious. Things of a day, what we are and what not? Man is a dream of shadows.[24] [Plates 13–26.]

In 1927, several years before surrealism made its official debut in America at the Wadsworth Atheneum in 1931 and the Julien Levy Gallery in 1932, Bruguière had exhibited these and his other experiments at the Art Center in New York.[25] This exhibition, arranged by the Pictorial Photographers of America, included ninety-four photographs and ten paintings.[26] It was Bruguière's first major one-man exhibition in New York or anywhere else, and the critics, taken by surprise, wrote reviews of unprecedented admiration. Full-page coverage of the exhibition appeared in *The New York Times*, the *Boston Evening Transcript*, the *Christian Science Monitor*, and the *Brooklyn Eagle*, among others. The reviews excitedly attributed to Bruguière the almost single-handed discovery of photography as modern art. He was compared to Stieglitz[27] and Brancusi[28] and credited with the invention of multiple exposure (Plates 27–31). For example, the critic for the *Brooklyn Eagle* wrote (April 3, 1927):

> The process which Bruguière invented, that of the double exposure, allows for much greater compositional leeway than was ever before possible. It will probably come as a surprise to most people that it was Bruguière who introduced this effect into Germany, which has since been so largely taken over by the German films. The curious double exposure effects used in such films as "Variety," "Metropolis," and "Faust" are all derived from his work.

The photographs from *The Way* had been sent and circulated among the cameramen of the UFA Studios (the major motion picture production corporation in Germany during the twenties and thirties) to generate interest in funding the film, and no doubt the surrealist nature of the photographs, perhaps more than the multiple-exposure technique, influenced those who saw them. But the films mentioned in the *Brooklyn Eagle* were made in 1925 and 1926 and could hardly have depended on *The Way*, which was in progress in 1925. Moreover, the surreal and expressionist films of the golden age of UFA were more likely linked to René Clair, Abel Gance, Man Ray, and Hans Richter.[29]

Also, *Warning Shadows* by Arthur Robinson and *The Last Laugh*, a UFA film by F. W. Murnau, used effects similar to Bruguière's multiple exposures and were made in 1923 and 1924 respectively.[30]

Although Bruguière was certainly one of the first photographers to use multiple exposure in a concentrated, creative effort, he was by no means its inventor. As early as 1860, a few anonymous photographers were producing "spirit photographs," in which they claimed to be able to record photographically the spirits of the dead in the presence of the living. In his book *Creative Photography*, Aaron Scharf has written: "In spirit photography we may have the first effective, if not artful, use of multiple-exposed and superimposed images."[31]

The unique character of Bruguière's images and their contribution to surrealism apparently eluded the critics and viewers of 1927—no mention of them was ever made.

It is an interesting coincidence, or perhaps something more, that in 1924–1925, when Bruguière was photographing *The Way*, André Breton published the first Surrealist Manifesto. Even more intriguing is the similarity between Bruguière's description of his scenario (page 26) and excerpts from Breton's manifesto:

> Man, that inveterate dreamer, daily more discontent with his destiny, has trouble assessing the objects he has been led to use, objects that his nonchalance has brought his way, . . . he knows what women he has had, what silly affairs he has been involved in; he is unimpressed by his wealth or poverty, in this respect he is still a newborn babe. . . . the absence of any known restrictions allows him the perspective of several lives lived at once.[32]

Bruguière was a prolific reader, who exchanged books by mail with his friends, yet there is nothing in his notes or letters to suggest that he had ever read the manifesto. There were, of course, articles in *Camera Work* as early as 1911, of which Bruguière had probably been aware. For example, in *Camera Work*, No. 36, Benjamin De Casseres wrote on "The Unconscious in Art." In defining the artist's conscious link to the unconscious, his statement: "Imagination is the dream of the unconscious," is remarkably close to Bruguière's surrealist statement: "Man is a dream of shadows." Bruguière's surrealism, possibly conceived independently, is epitomized by this statement, and Breton, expressing the same idea, wrote: "man, when he ceases to sleep, is above all the plaything of his memory."[33] Both statements advocate an imagery which describes the inherent psychological nature of creative expression itself.

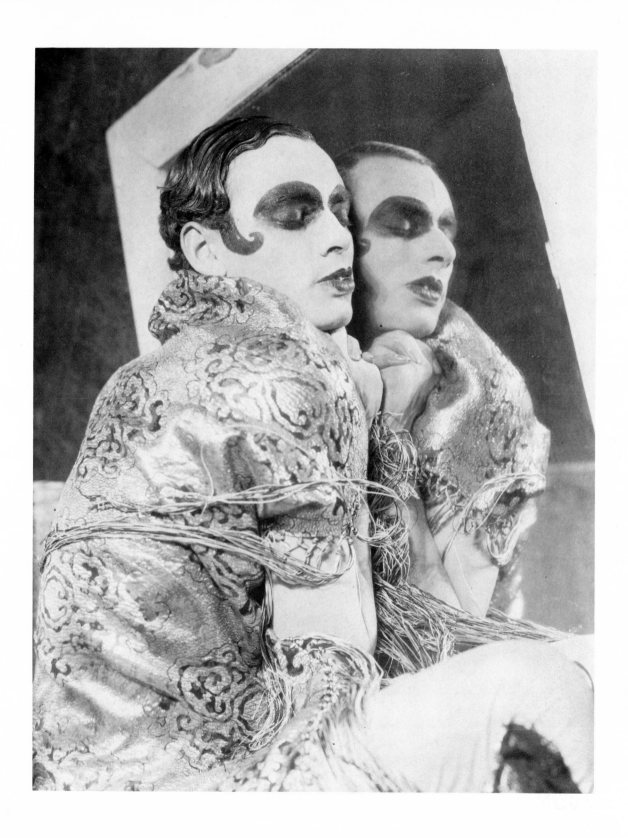

13 From *The Way*, c. 1923–25

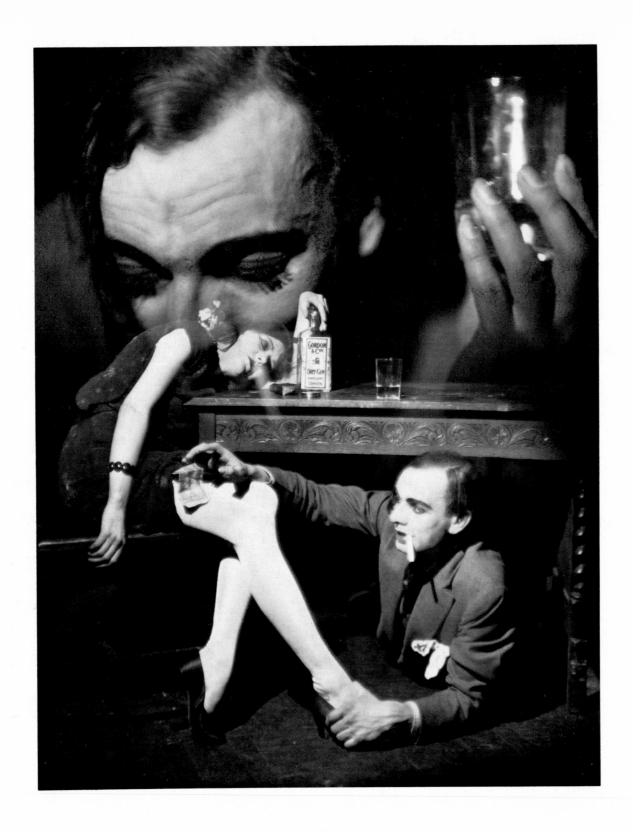

14 and 15　From *The Way*, c. 1923–25

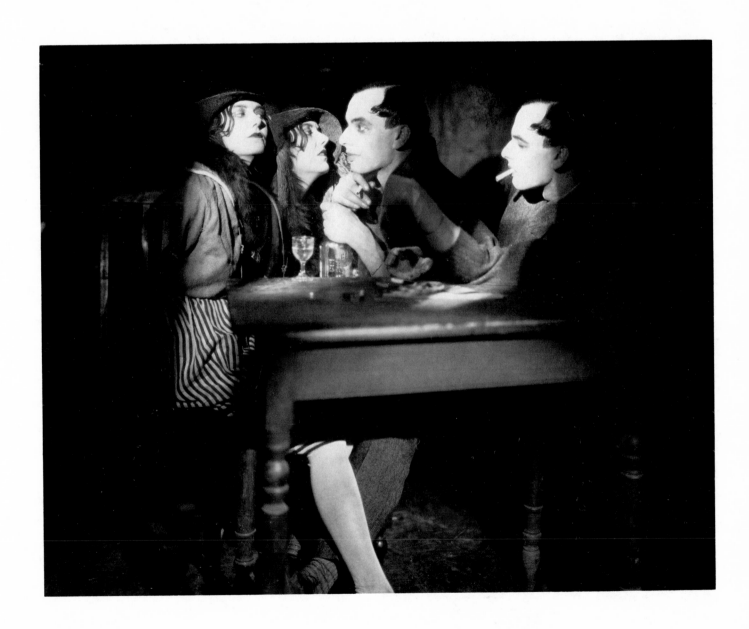

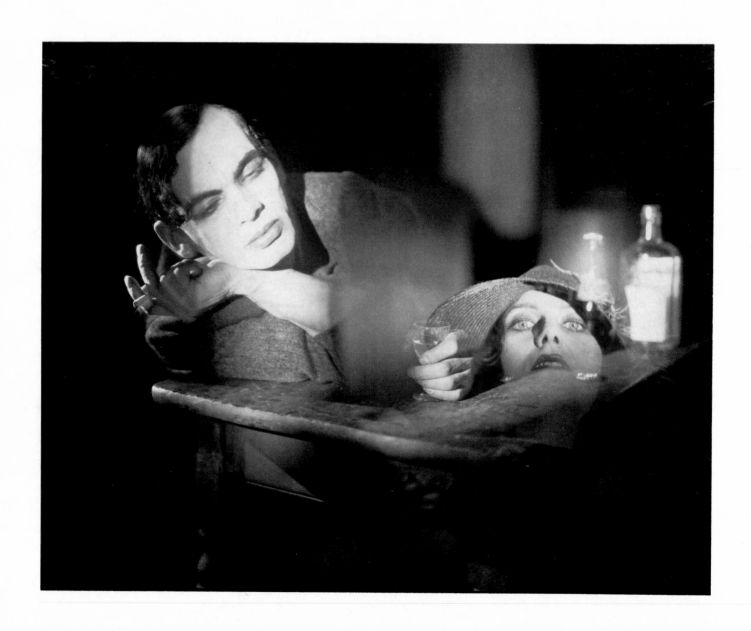

16 and 17 From *The Way*, c. 1923–25

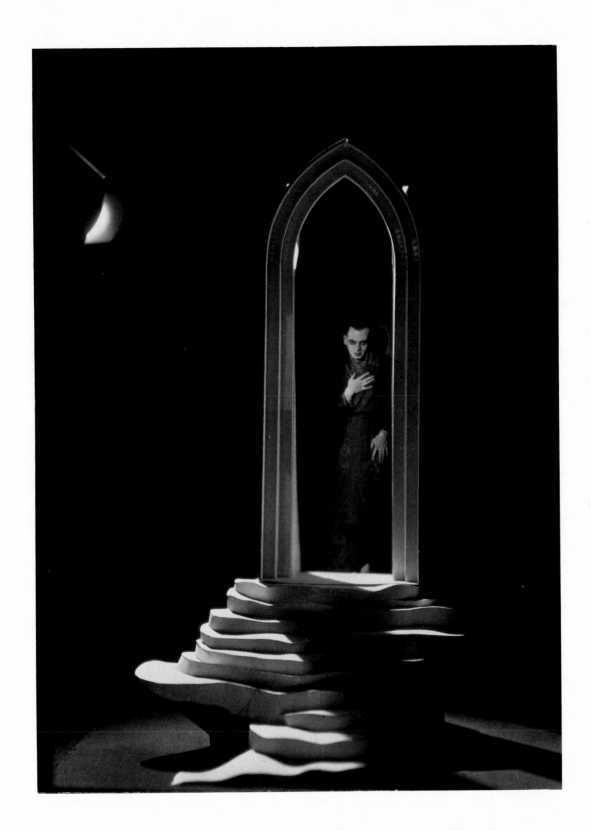

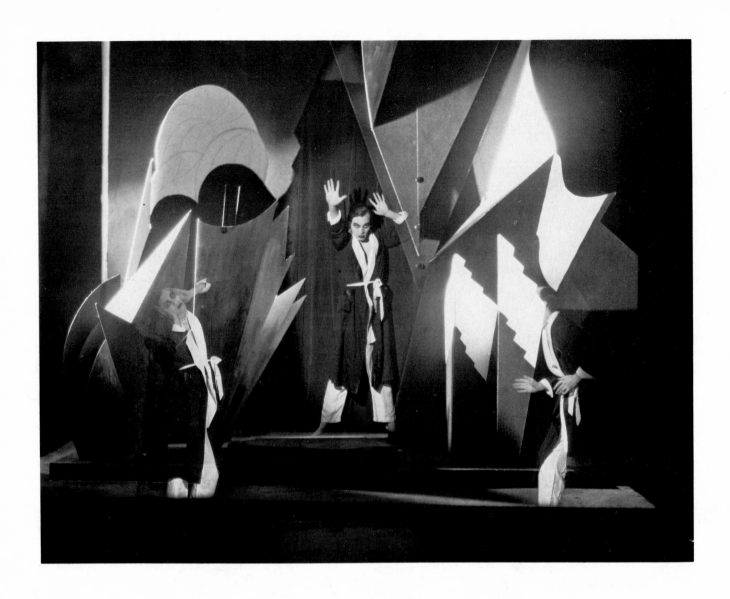

18 and 19 From *The Way*, c. 1923–25

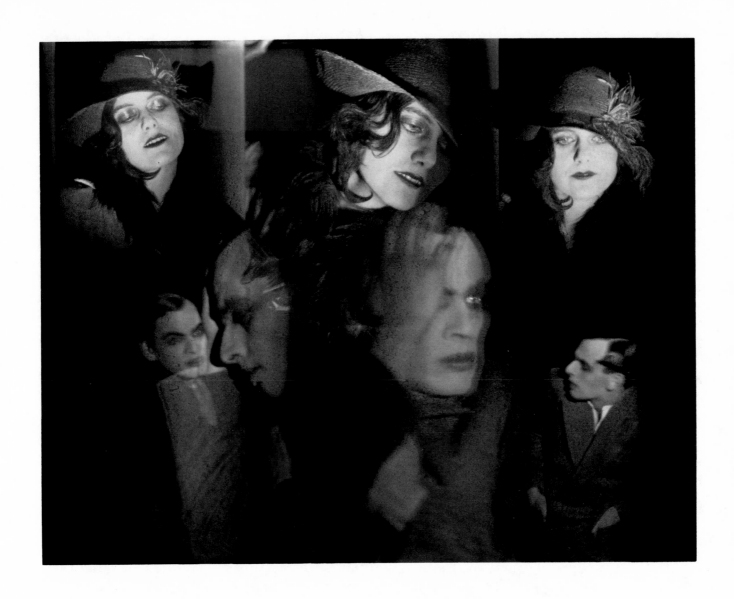

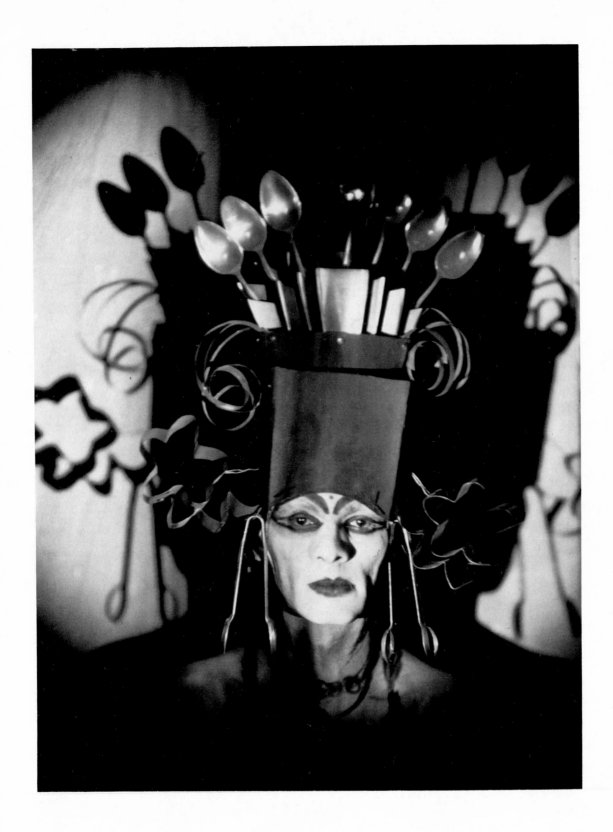

20 and 21 From *The Way*, c. 1923–25

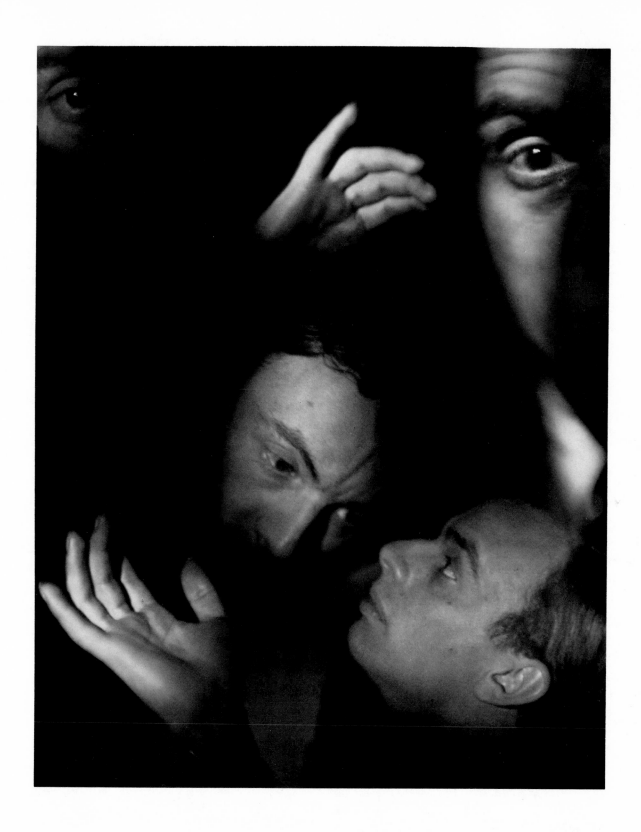

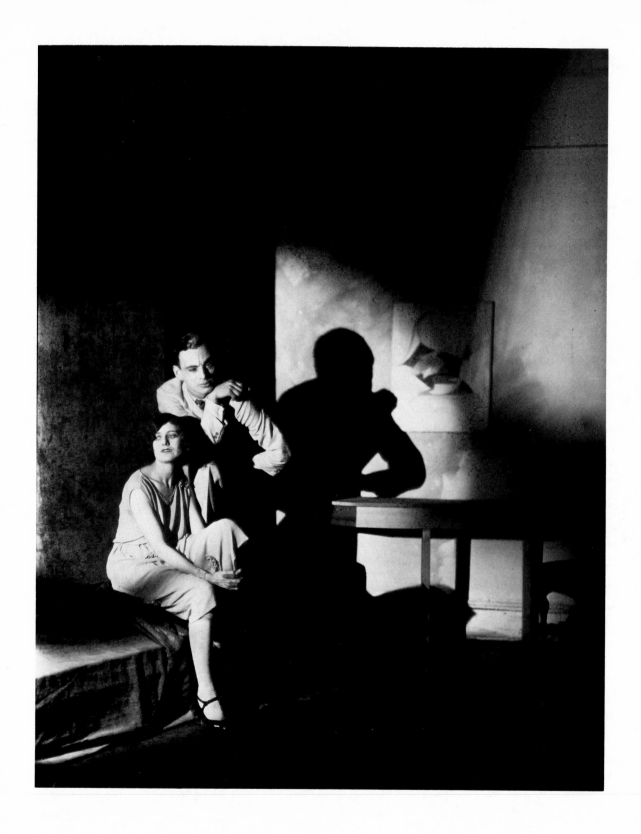

22 and 23 From *The Way*, c. 1923–25

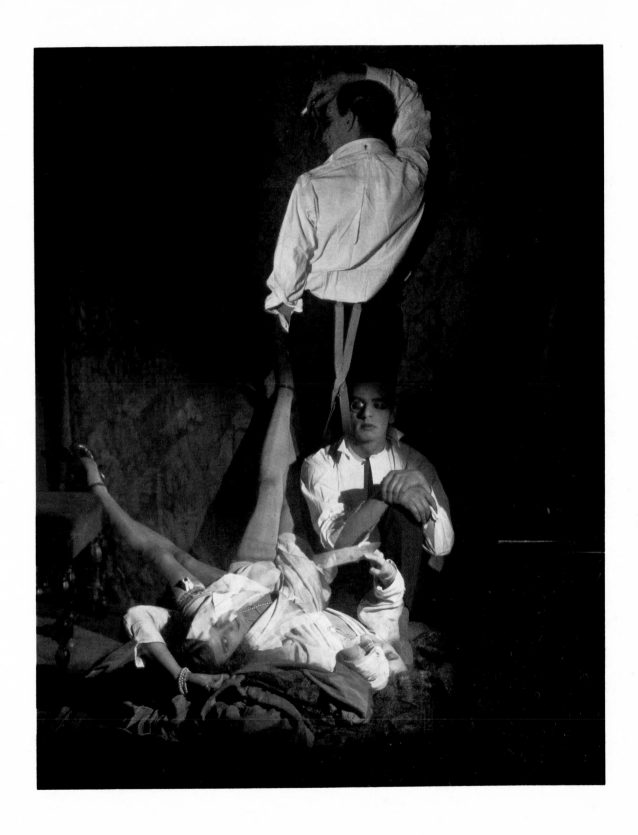

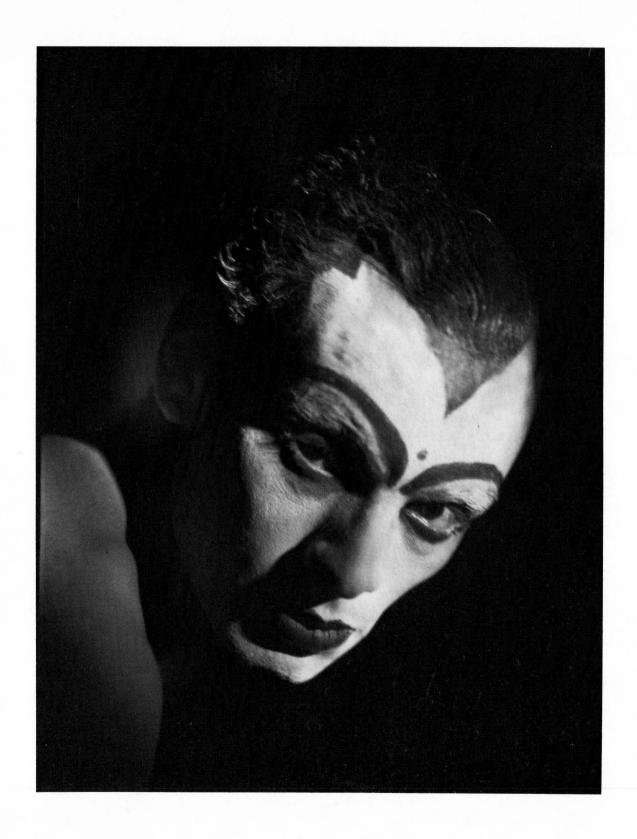

24 and 25　From *The Way*, c. 1923–25

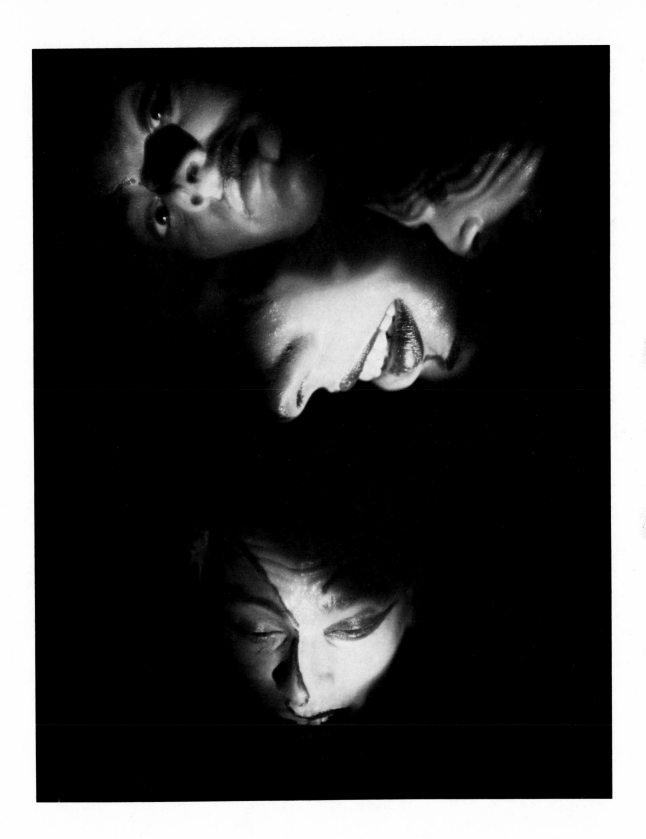

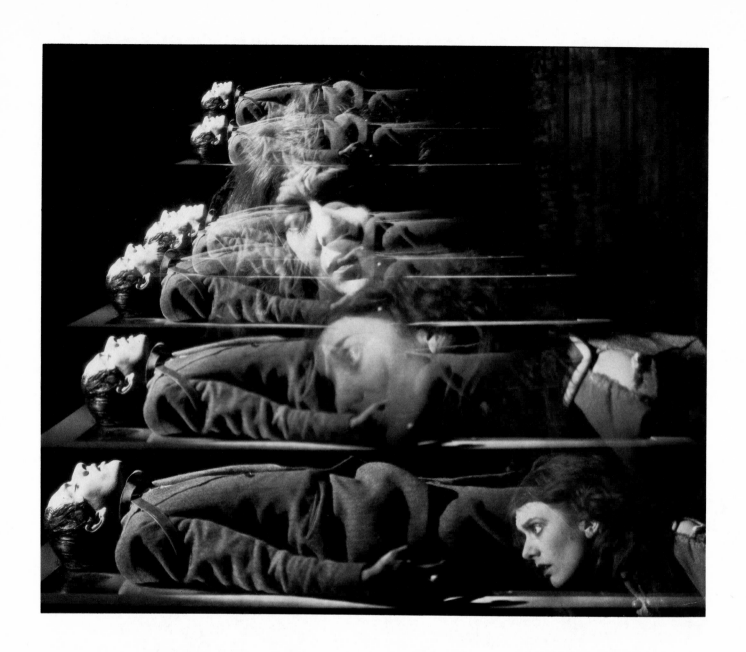

26 From *The Way*, c. 1923–25

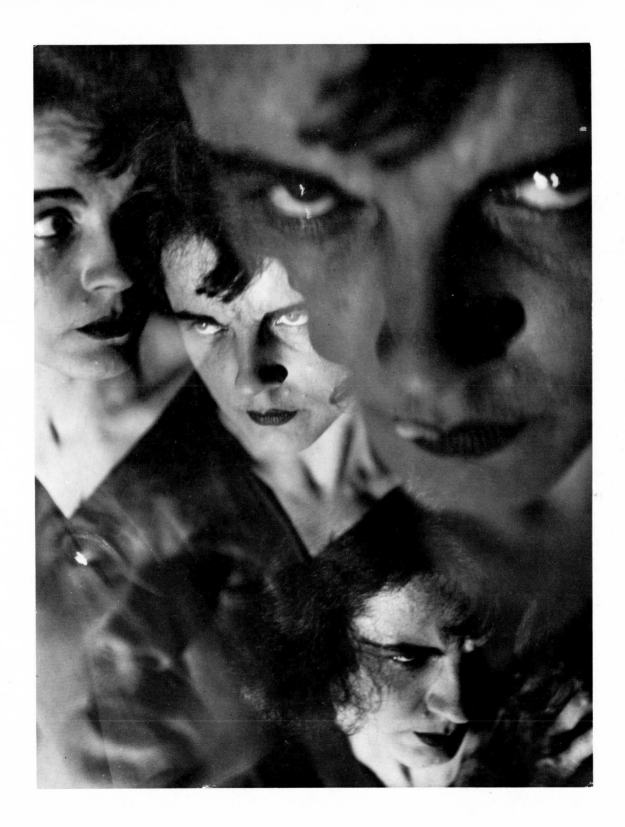

27 "Experiment," c. 1925

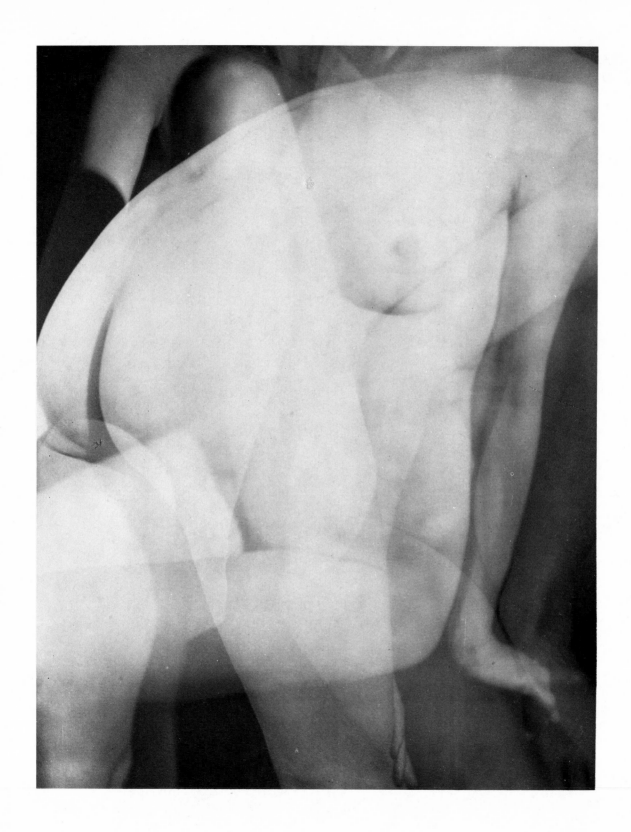

28 and 29 "Experiment," c. 1926

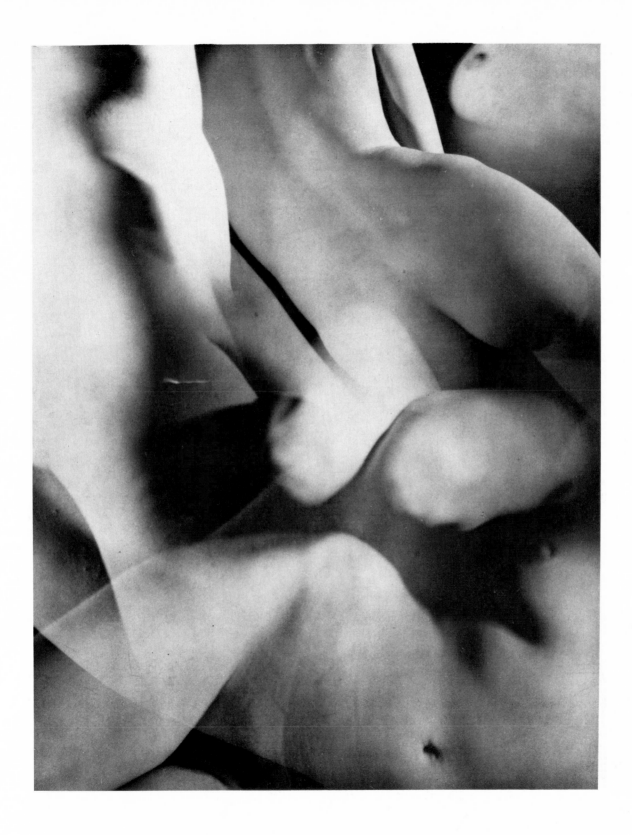

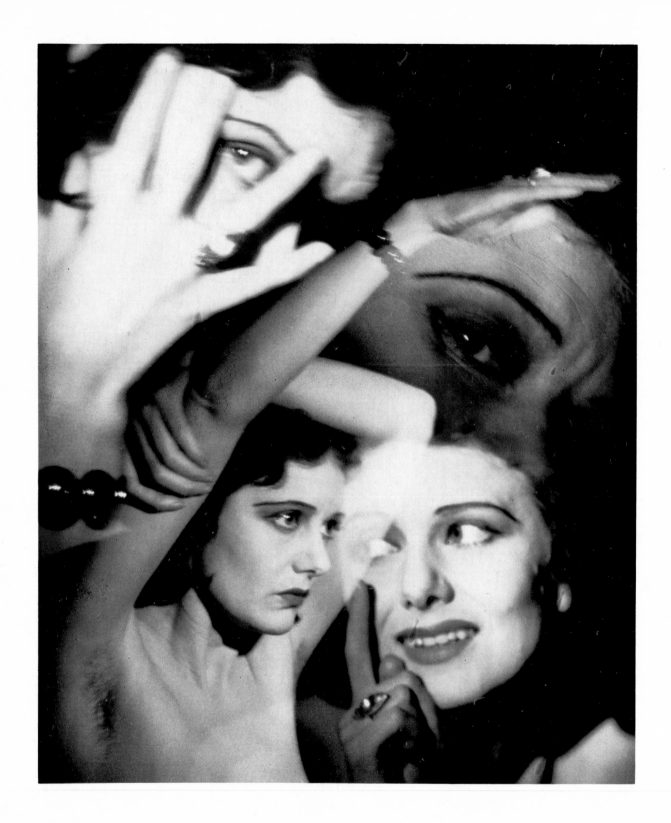

30 and 31 "Experiment," c. 1925

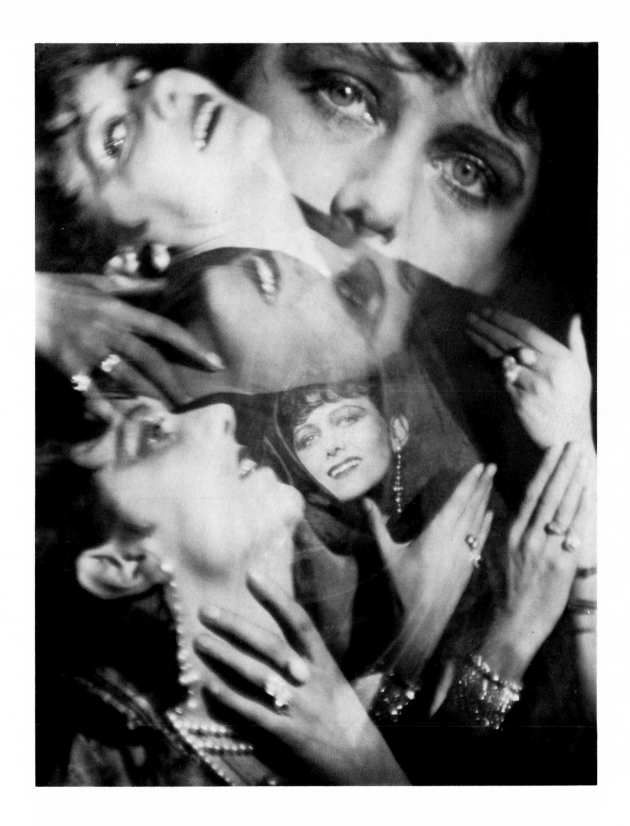

In another of Bruguière's notes, found among those dating from 1924, was a handwritten quote taken from Nietzsche's collection of aphorisms known as *Human, All-Too-Human* ("The Logic of the Dream"):

In our sleep and in our dreams we pass thru the whole thought of earlier humanity. I mean the same way man reasons in his dreams he reasoned in a waking state for many thousands of years. The first cause which occurred to his mind in reference to anything that needed explanation satisfied him and passed for truth. In the dream this atavistic relic of humanity manifests itself within us, for it is the foundation upon which the higher rational faculty developed and which is still developing in every individual. The dream carries us back to earlier stages of human culture and affords us a means of understanding it better.[34]

The early date of this note on Nietzsche's work is further evidence of Bruguière's attempt to understand and create images based on a dream concept and lends a certain amount of credence to the idea that he may have developed his own sense of surrealism independent of the larger surrealist movement. Bruguière's surrealism was not so much a part of the social revolutionary commitment, common to the European advocates, as it was an attempt to free photography from its role as a purveyor of reality. *The Way* avoids the Freudian automatism of Man Ray, Duchamp, and Picabia and is more nearly related to the controlled dream images of René Magritte.[35]

The photographs for *The Way* were conceived as a visual scenario for a film and as such retain many of the characteristics inherent to film and theatre. The use of stage spots and floods, as well as the dramatized situations, create in the images a sense of fantasy generally associated with theatre and film. Also, some of the photographs use German expressionist-like sets which, in their symbolic rather than illusionary representation of reality, are reminiscent of early films like *The Cabinet of Dr. Caligari*. Additionally, the multiple-exposed images, engulfed in dense black backgrounds, create an illusion of motion or time change which is characteristic of film. In a contemporary view, these photographs have their counterparts in the work of Les Krims, Duane Michaels, and Arthur Tress, who also stage and create the situations for the subjects of their photographs.

Beaumont Newhall's analysis of the 1920s revealed that photogra-

phy was moving in two distinct directions: "the direct use of the camera to bring us face to face, as it were, with the thing itself in all its substance and texture; and the exploration of a fresh vision of the world, conforming neither to tradition nor convention, and the creation of abstract, even autonomous, images unrelated to realism."[36] Bruguière belonged to the latter persuasion and simultaneously with his surrealist experiments he was developing his light abstractions, for which he is most remembered. It is these works which are the most strikingly original in technique and imagery and have earned for Bruguière a unique place in history. At least three different influences contributed to the evolution of the light abstractions: Bruguière's desire to create a psychologically relevant art form; his response to the general modern art aesthetic of the time, deriving technique and style from both technical experiments and a specific painting style; and his desire for the photographs to evoke visual pleasure as "designs in abstract forms of light."

Analogous to Bruguière's use of light as the principal agent of form was the desire of Morgan Russell (an American Synchromist painter) to paint "solely by means of color and the way it is put down, in showers and broad patches, distinct from each other or blended, but with force and clearness, and with large geometric patterns, with the effect of the whole as being constructed with volumes of color"[37] (Plates 32–33). In order to emphasize the dimensional or sculptural qualities of his light abstractions, Bruguière used shaped or cut-paper designs. These shapes were defined and interrupted by a separate interplay of light and shadow, and the abstract shapes were reminiscent of the Synchromists' style. However, an even closer relationship existed between Bruguière's abstractions and Synchromism: a common philosophical concern with the basic characteristics of the respective mediums—color as form / light as form—and the desire for a totally abstract result (Plate 34).

Of all those who reviewed the Art Center exhibition in 1927, only *The New York Times* seems to have understood the relationship between Bruguière's paintings and photographs:

The paintings and watercolors play a minor role, that is, in themselves they have no special significance. But in their plastic relationship to the photographs, the abstract forms of the paintings and watercolors accent one's impression that Mr. Bruguière possesses an appreciative eye for the possibilities of form and its arbitrary

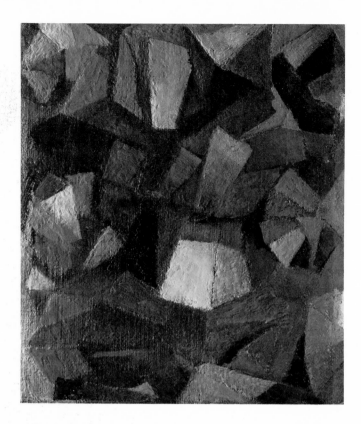

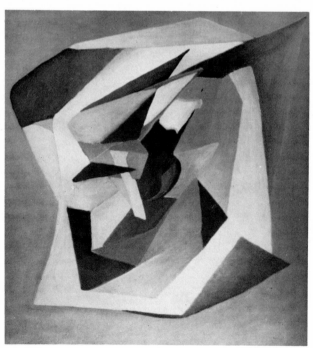

32 *Creavit Deus Hominem (Synchromy Number 3: Color Counterpoint)*, by Morgan Russell, 1913

33 Abstract oil painting by Bruguière, c. 1920

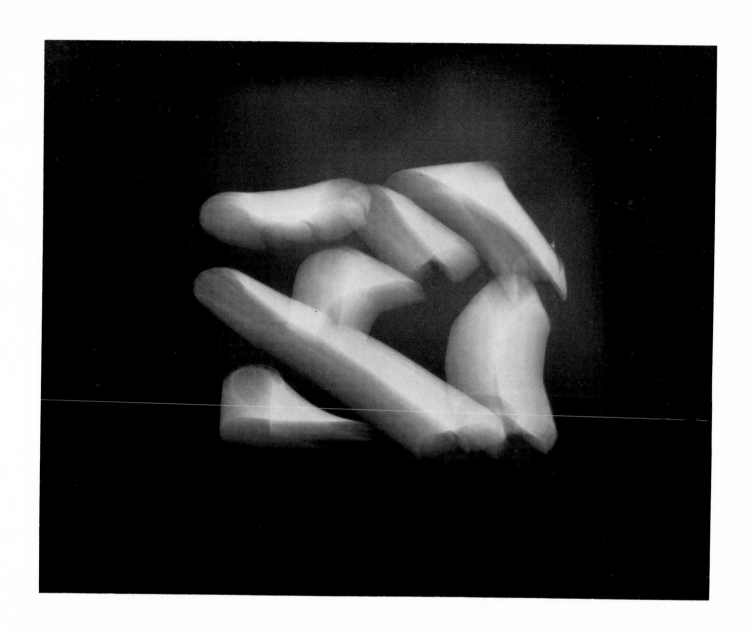

34 Light abstraction, c. 1923–24

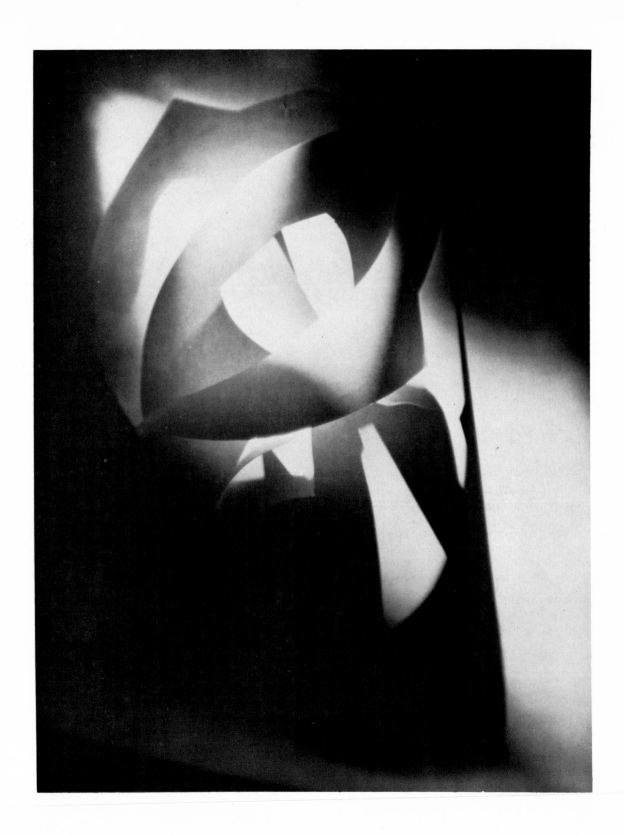

35 Cut-paper abstraction, c. 1921–22

arrangement in the apparently intangible contours of light. For the thin, unrealized abstractions of his painted works become hard, three dimensional realities in his photographed works.[38] [Plate 35.]

Bruguière's method of recording the stage designer's productions with the camera lens continuously open, while the situation changed, was basically the same process he used in making his first light abstractions.[39] His control of the subtleties of tone, through multiple exposure, also contributed to the intricacy and sophistication of the image. The most interesting influence on Bruguière's method of photographing light came not from his own experiments or from the art world, but from the theatre. In 1921 Bruguière photographed a series of colored light compositions from the "color organ" of Thomas Wilfred. These photographs and an article by Stark Young on Wilfred's color organ appeared in the January 1922 issue of *Theatre Arts*. Bruguière's records of the projections of Wilfred's marvelous machine were the first instance of his photographing unadulterated light as form[40] (Plates 36–37).

The color organ, or "clavilux," as Wilfred called it, was a keyboard instrument resembling a musical organ, which produced "mobile" or changing shapes of colored light on a screen in the front of a darkened theatre (Plate 38).

It [the clavilux] consists first of all of two separate units. Instead of the wind chest there are a number of sources of white light. And in the white light all possibilities of color lie as all sounds in the wind. . . . The light passes through an instrument, a combination of the mechanical, electrical and optical, which is controlled by the keyboard. A setting of the stops and a pressure of the keys releases the neutral white light and puts it to work as wind is put to work in an organ, leads it to definite sources of color and form. Thus the result at all times must depend on the white screen upon which the light rays are arrested and thereby translated into a visual experience. When you sit at the keyboard you first select your form that is to open the composition, your solo figure; then you select your color and the way it is to be introduced as a plain rising or falling mass of color; or it may come in fibres, interlacing, juxtaposing or superimposing. Then your form may move independently of your color, the two may move together, or either one move while the other remains stationary. Or several forms may be introduced, moving in different rhythms, thus creating a visual counterpoint.[41]

The remarkable resemblance between these photographs by Bru-

guière and his own light abstractions can leave little doubt as to the impact the experience held for him. Indeed, Stark Young's opening remarks in the article surely stirred Bruguière's sense of experimental freedom:

> What we really found there [the mobile color compositions] was all abstraction. . . . Painting at times has approached this abstraction, in pure design always, in the primitive art, and again in the schools of modern art. But Kandinsky and Stella and the rest are bounded forever by their medium; their canvas once done is static. . . . Mobile color does not exist in material mediums but rather in light itself.[42]

Bruguière's own words written at about the same time indicated that the clavilux experience and his photographs were inextricably linked:

> The fourth dimension . . . that is the effect I have long wanted to give. The effect of movement in the eye of the beholder, though the object itself was absolutely stationary when photographed.[43]

His ideal was realized when, in 1929, he showed his work to film and photography critic Harry Alan Potamkin:

> When Bruguière first showed them to me, I experienced the sensation of "flight," "panic," etc. This indicates that the pictures though stationary suggested kinetic qualities, qualities of the movie.[44] [Plates 39–51.]

Walter Chappell, who wrote an article on Bruguière for *Art in America* in 1959, felt these works had attempted to "apprehend light as an active symbol of consciousness,"[45] and in this regard Bruguière had written:

> I very early realized that people think on different planes of consciousness. Only those who think on the same plane can ever hope to understand each other, and just as we think, so we work on that plane.[46]

Bruguière apparently had little contact with Man Ray and Moholy-Nagy, although it is known through letters from Bruguière's son that Moholy-Nagy included Bruguière's work in his lectures on abstractionism.[47] If these artists had anything in common, it would probably be

the independent manner in which each arrived at a unique and innovative imagery.

Thirty of Bruguière's "designs in abstract forms of light" were included in the 1927 Art Center exhibition. In 1928 the majority of the exhibition was shown at Der Sturm Galleries in Berlin, and as a result, Bruguière was made an honorary member of the German Secessionists (a group of artists who had split with the art world, with much the same aims of the Photo-Secession in America). That same year, Bruguière and Rosalinde Fuller moved to London, where Bruguière began a new series of experiments, including Britain's first abstract film, *Light Rhythms*.

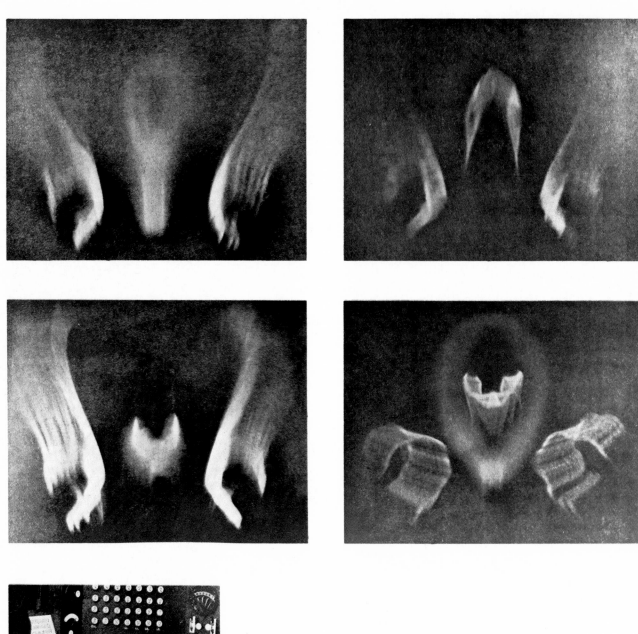

36 and 37 Thomas Wilfred's color organ projections, 1922

38 Thomas Wilfred's color organ, 1922

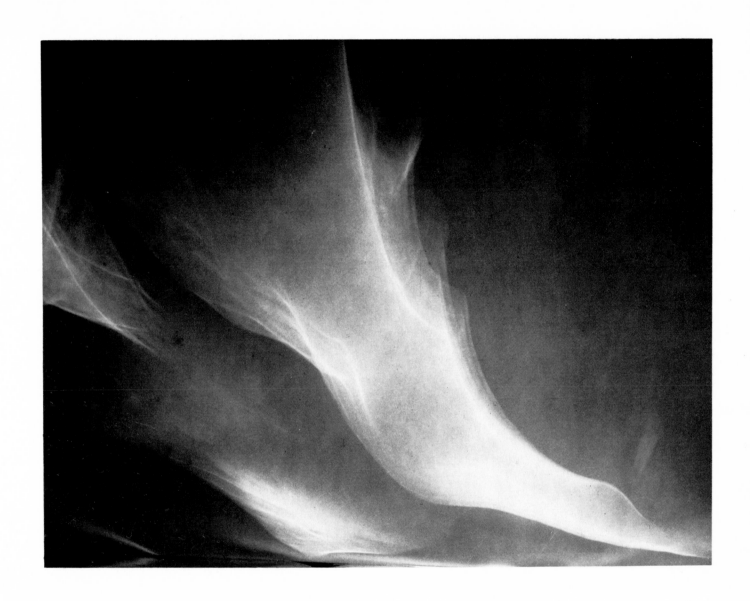

39 Light abstraction, c. 1925–27

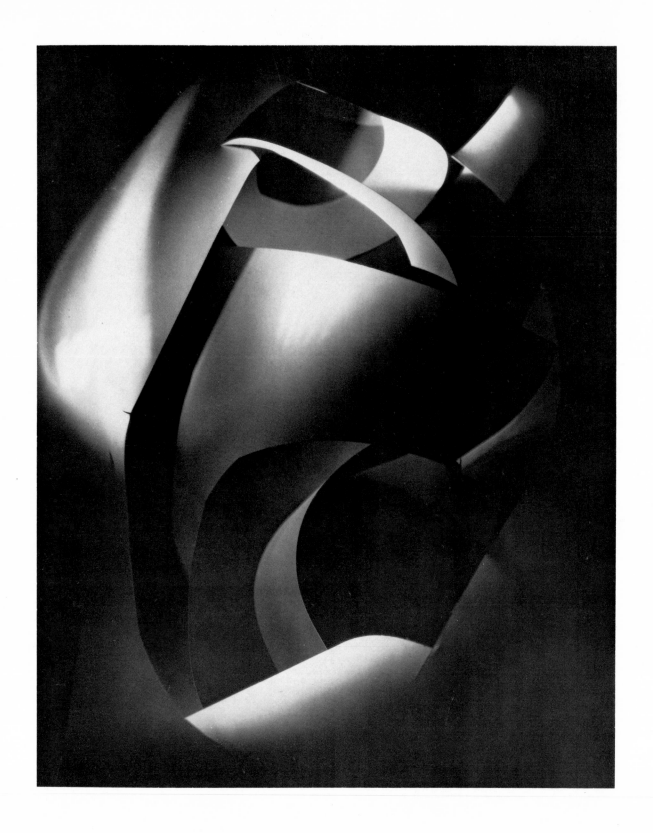

40 and 41 Cut-paper abstractions, c. 1927

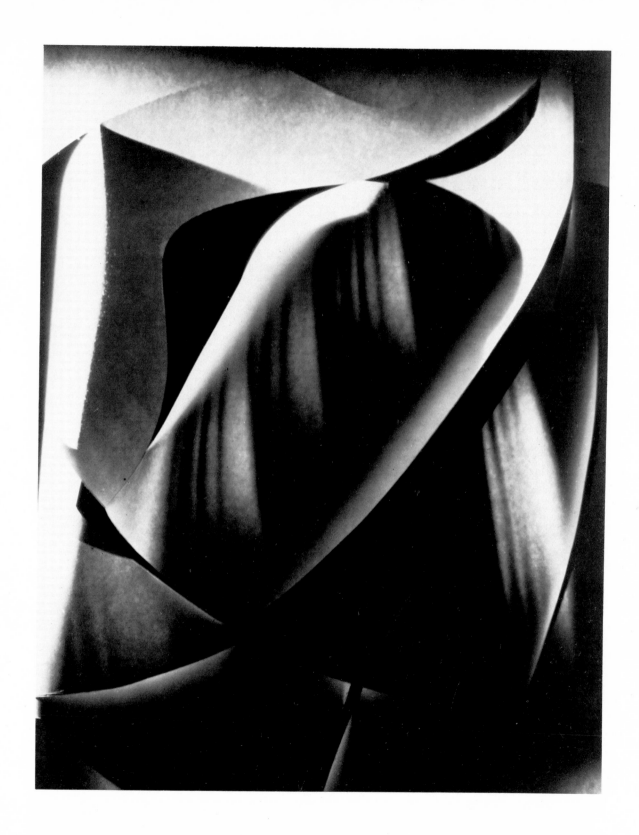

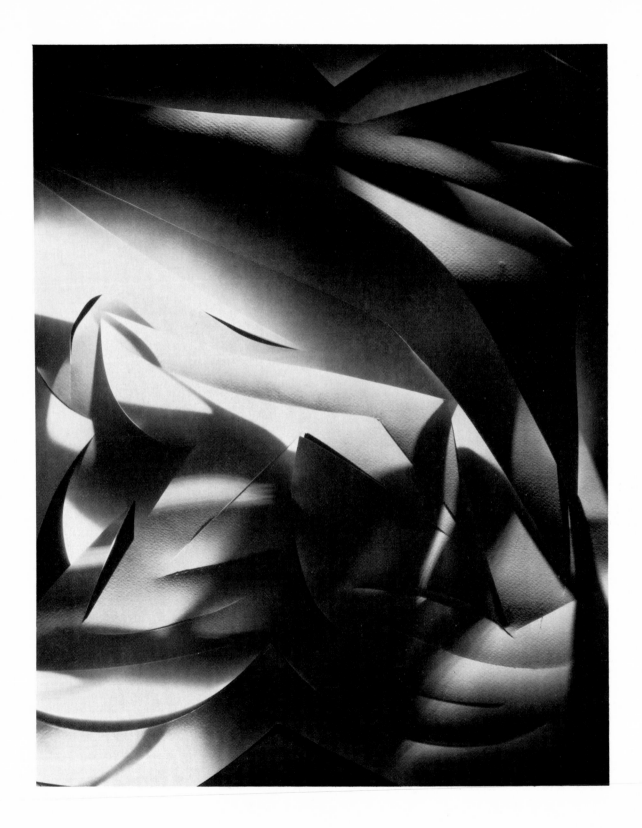

42 and 43 Cut-paper abstractions, c. 1927

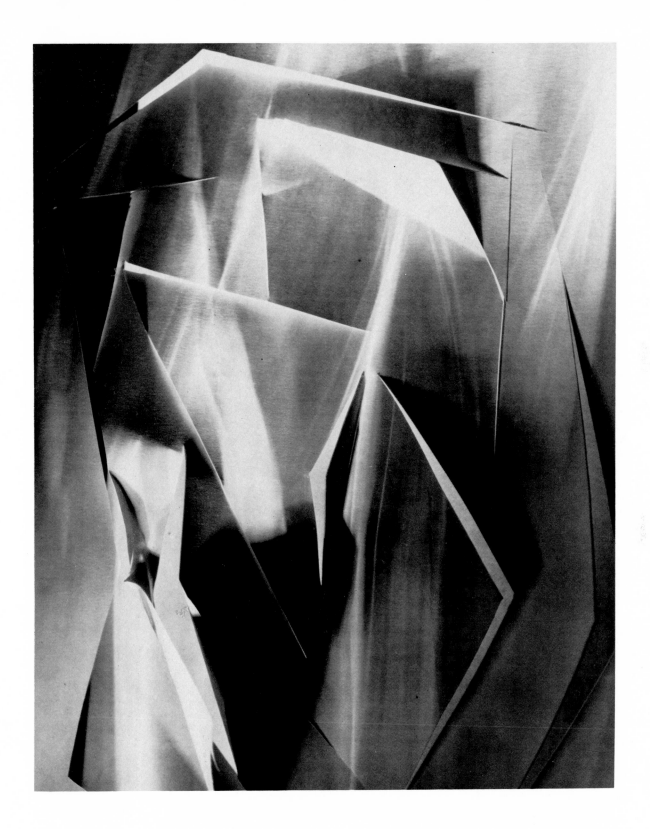

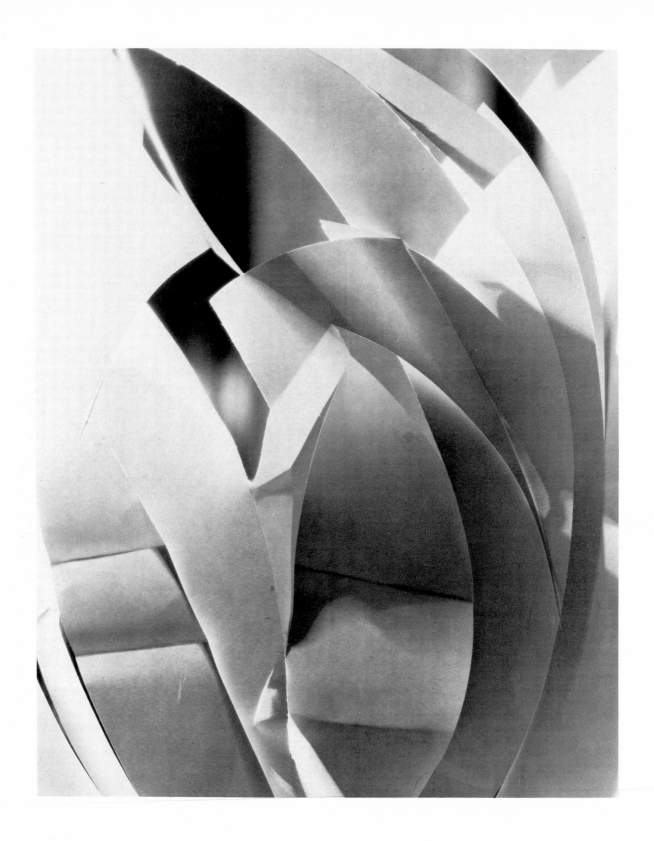

44 and 45 Cut-paper abstractions, c. 1927

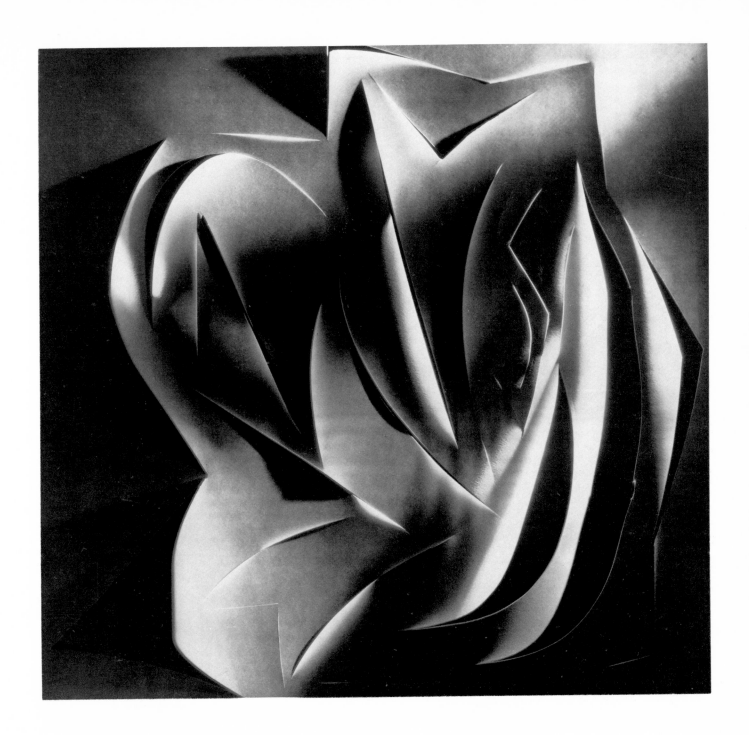

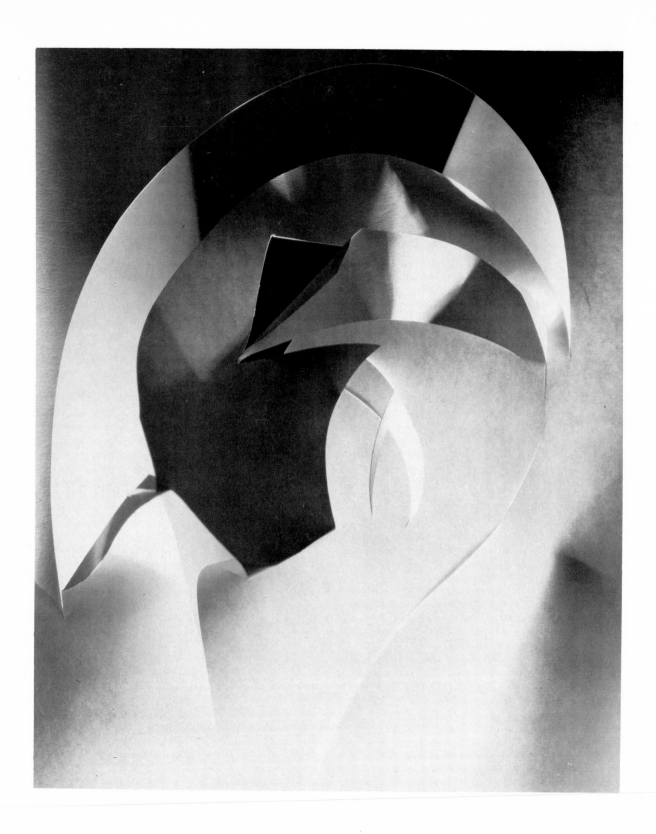

46 and 47 Cut-paper abstractions, c. 1927

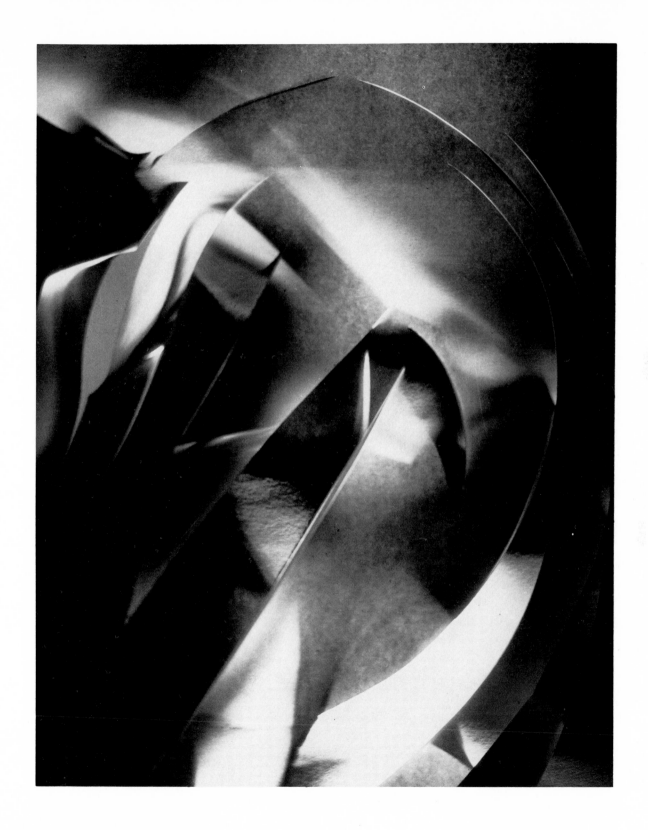

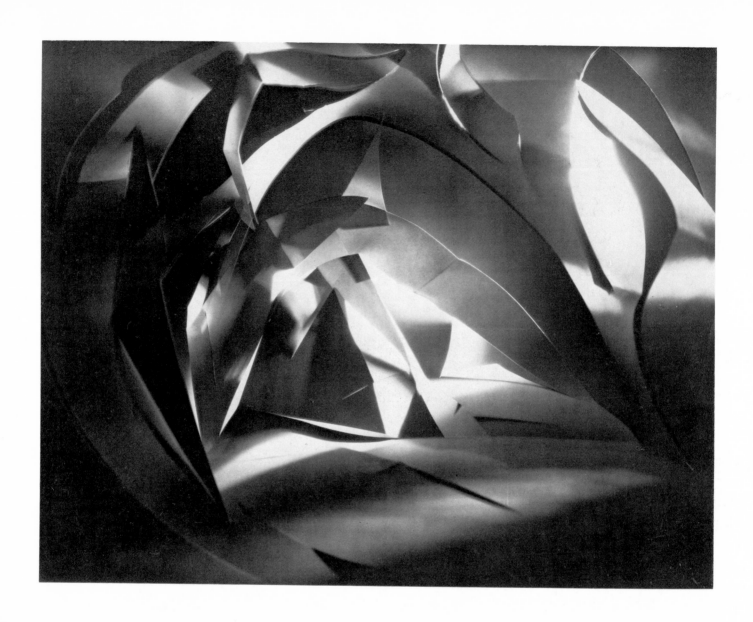

48 and 49 Cut-paper abstractions, c. 1927

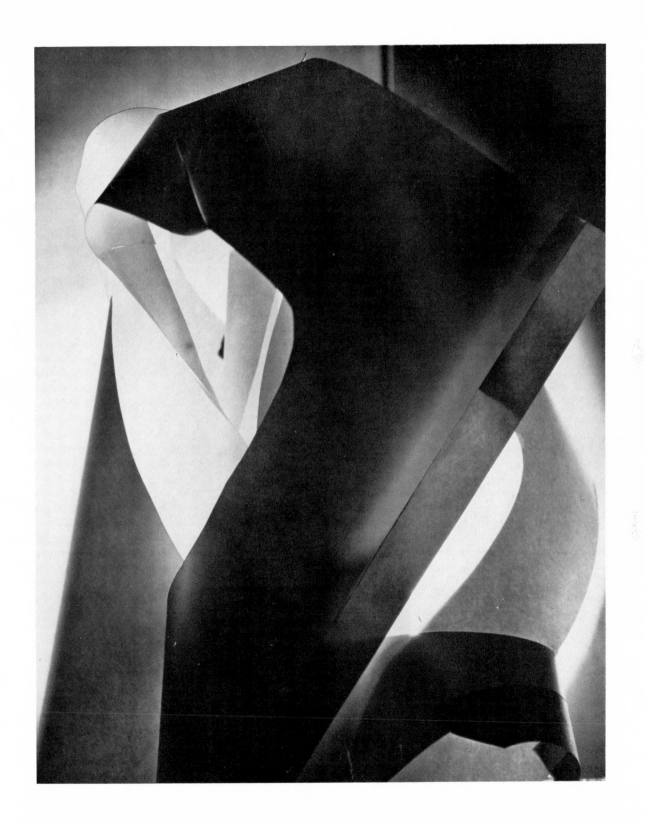

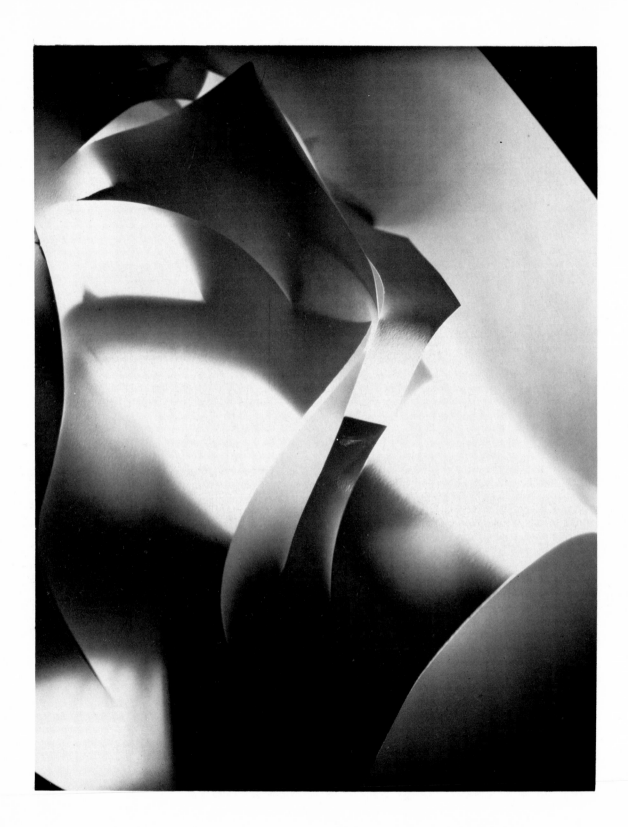

50 Cut-paper abstraction, c. 1927

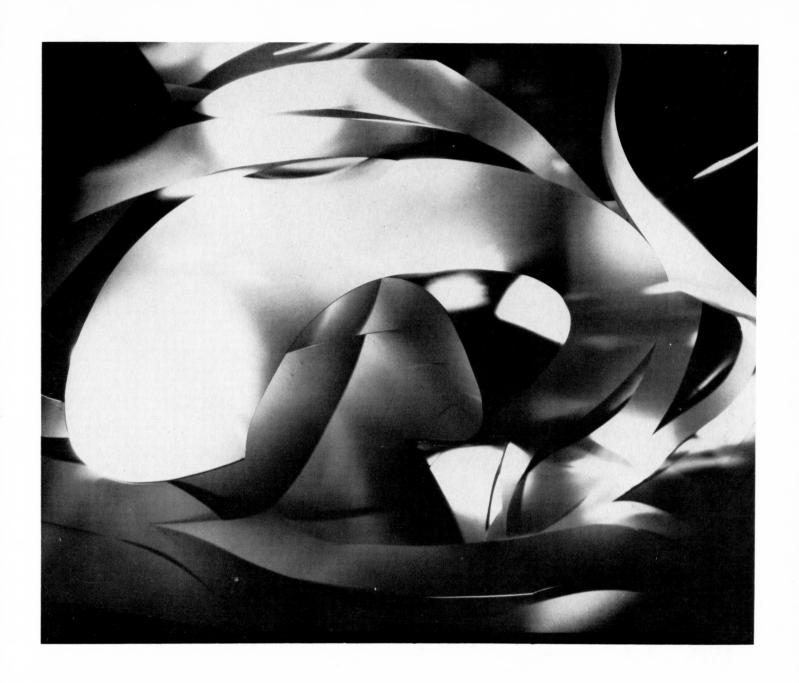

51 Cut-paper abstraction, c. 1925–27 73

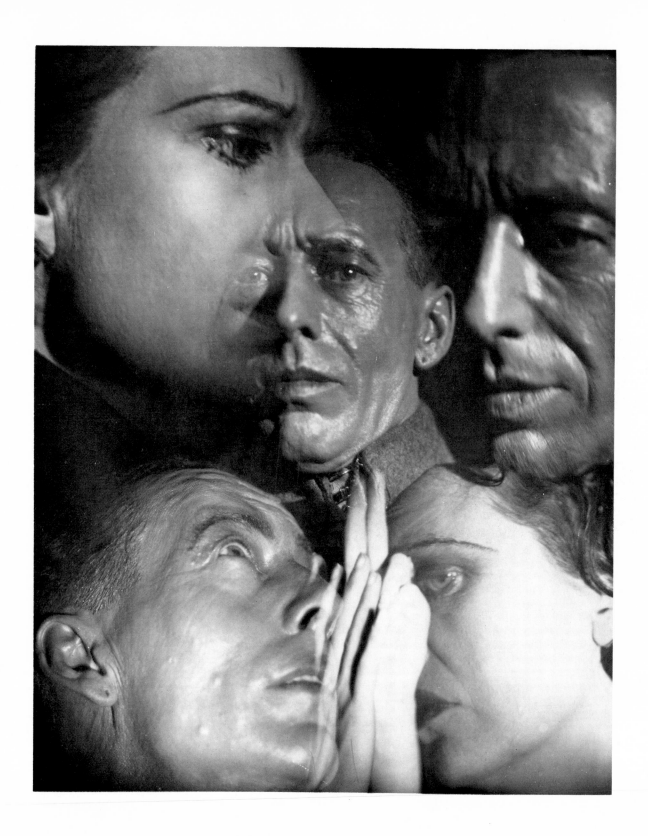

52 Multiple exposure, c. 1929

3

London
1928–1937

During the ten years following his move to London, Bruguière produced a body of work even greater in extent than in the previous decade. He had sold his commercial studio before he left New York, but did not establish one in London. Instead he devoted all his time to his experiments and worked on new ways of expanding the ideas he had developed in New York. He exhibited more than ever before, published his photographs in numerous periodicals and books, made several films (*Light Rhythms, Empire Buyers Are Empire Builders*), and a number of title scenes for commercial advertising films, and became the official designer for the gateway to the British Pavilion at the Paris Exposition in 1937. Many of the directions Bruguière's interests followed during this decade were influenced by two new friends, Oswell Blakeston and E. Mc-Knight Kauffer. Kauffer, originally from Montana, was regarded as England's foremost graphic designer and was largely responsible for

the establishment of graphic design as an art form during the twenties and thirties.[48]

Shortly after his arrival in London, Bruguière was interviewed by Oswell Blakeston, writer and film critic, for articles in *Close Up* and *Architectural Review*. Their acquaintance ripened into an immediate friendship and artistic collaboration. In the years that followed, Blakeston became the self-appointed agent for the exposition of Bruguière's work.

The multiple-exposure imagery that Bruguière had perfected in making *The Way* now became more complex in style. At times it merged with his light abstractions to become a new idea—multiple exposure the technique, and abstraction the motif. The result was an array of novel images alternating between light as form and abstracted forms defined by light (Plates 52–54).

In New York, Bruguière's multiple exposures and light abstractions had expressed two separate aesthetic concerns. In England, however, Bruguière attempted to combine the two ideas, and although they remained essentially distinct, they were often mixed in his exhibitions and books as part of the same ideology.

In 1929 Bruguière was invited to show eleven of his photographs in the Deutsche Werkbund exhibition, "Film und Foto," at Stuttgart, which also included, among others, work by John Heartfield and Edward Steichen.[49] In the same year Bruguière published twenty-four new photographs in a book titled *Beyond This Point*, with a text by Lance Sieveking. The format recalled Bruguière's first book, *San Francisco, 1918*, in which the photographs were linked together by an original text in free prose.

An interesting parallel collaborative effort, published over a decade later, in 1941, was *Let Us Now Praise Famous Men*, by James Agee and Walker Evans. (A similar effort, in 1937, was *You Have Seen Their Faces*, by Erskine Caldwell and Margaret Bourke-White.) In *Let Us Now Praise Famous Men*, the text and the photographs coexist as separate entities in different sections of the book. In *Beyond This Point*, however, an attempt was made to integrate photographs with text. The book touches on several possible attitudes to three human crises: the approach of death; the urgings of jealousy; and the prospect of social ruin. In one section, for example, Sieveking describes the emotions of a wealthy man distraught at impending bankruptcy:

> Dinner was intolerable. . . . At the far end of the table sat your dear companion talking in the old inimitable way. Laughter floated

across you—. How bright were those eyes! Even now the news was on its way. . . . Why should you sit here any longer? Surely there was nothing to wait for—now? Only one thing was

The text breaks off and one of Bruguière's photographs is reproduced directly beneath. Then, at the bottom of the photograph, the text continues: "and the table jarred a little, a glass tinkled against another" (Plates 55–58). The two broken sentences, if joined together, do not make a complete thought. Bruguière's abstraction, which separates the two thoughts, is intended to express emotional and psychological responses. At times the method is successful; the reader pauses to contemplate the circumstances and is drawn deeper into the emotional situation that is being created. The effect is somewhat like the experience of listening to certain kinds of music while looking at related visual images.

Where *Let Us Now Praise Famous Men* was an attempt to document the conditions of tenant farm families and evoke a reaction from the reader, *Beyond This Point* attempted virtually to manifest the emotions of individuals as they experienced a given situation. The photographs included, a mixture of multiple exposures and abstract designs, are occasionally among Bruguière's best. In a few instances, Bruguière seemed to suppress his own intuitions in favor of a more literal image, which resulted in a static quality not evident in the majority of his work.

Sadakichi Hartmann—photography critic, poet, and regular contributor to *Camera Work*—was a close friend of Bruguière's and during the 1930s their correspondence often discussed Hartmann's books and Bruguière's photographs. In the following letter, Hartmann wrote a critical response to Bruguière about *Beyond This Point*:

Dear Prince: . . . I like your inventions, constructions but feel too much the knife, the cut, the sharp incision, so 4 57 67 75 and 107 are the best—those that show actual faces, pardon me, are atrocious, not technically but as expression.[50]

Hartmann's criticism of the "knife, the cut, the sharp incision" reflects a certain loss of spontaneity in some of the cut-paper abstractions, and his comment about those that "show actual faces" refers to the multiple exposures, which were too literal for his taste. The book was nevertheless an interesting idea and was the first major publication of Bruguière's work.

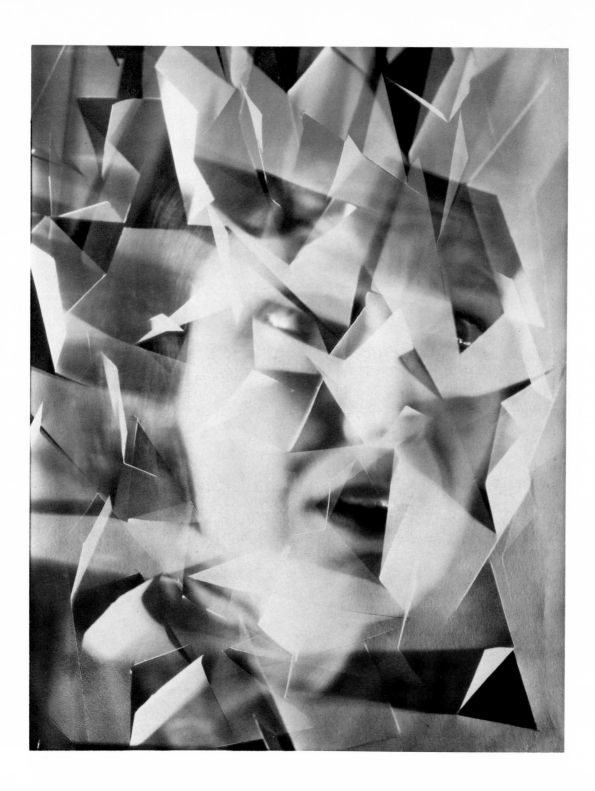

53 Multiple exposure, c. 1928–29

54 Multiple exposure, c. 1929

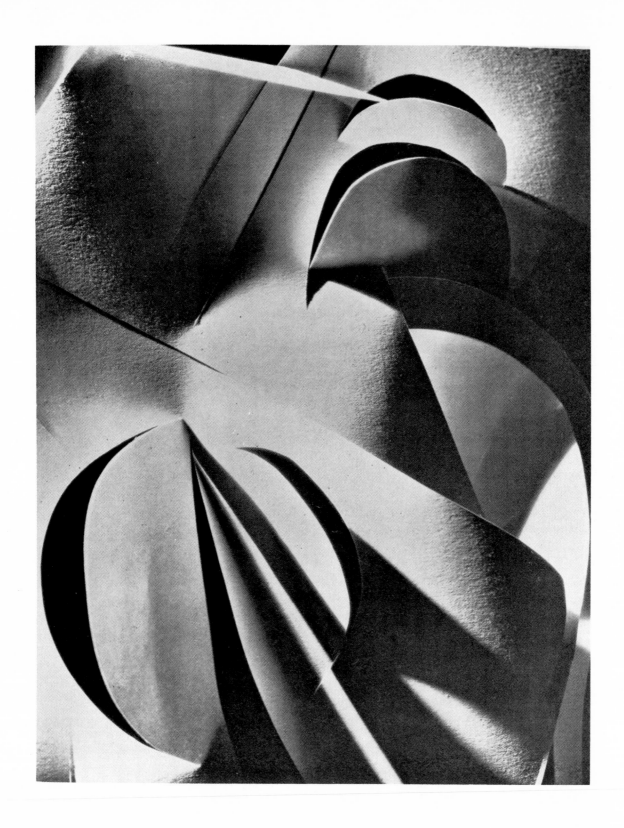

55 and 56 From *Beyond This Point*, 1929

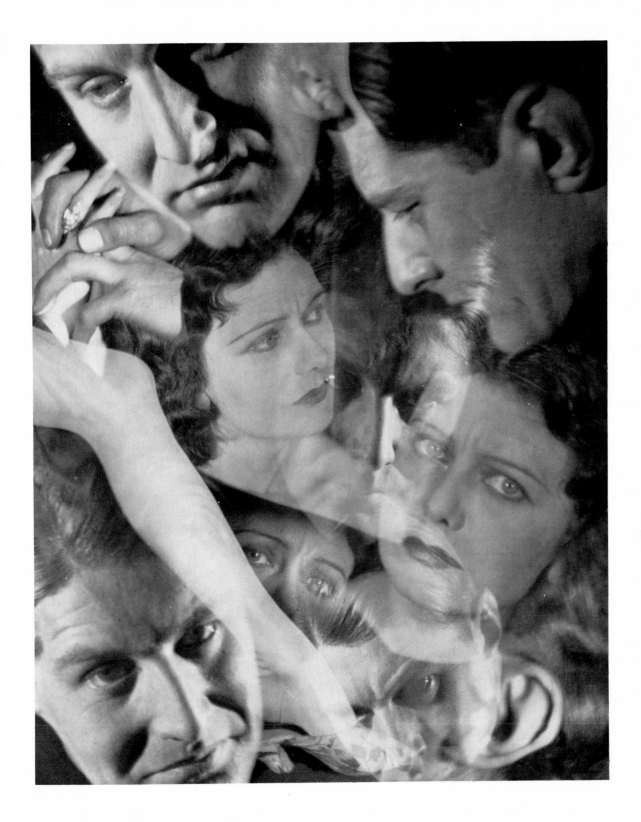

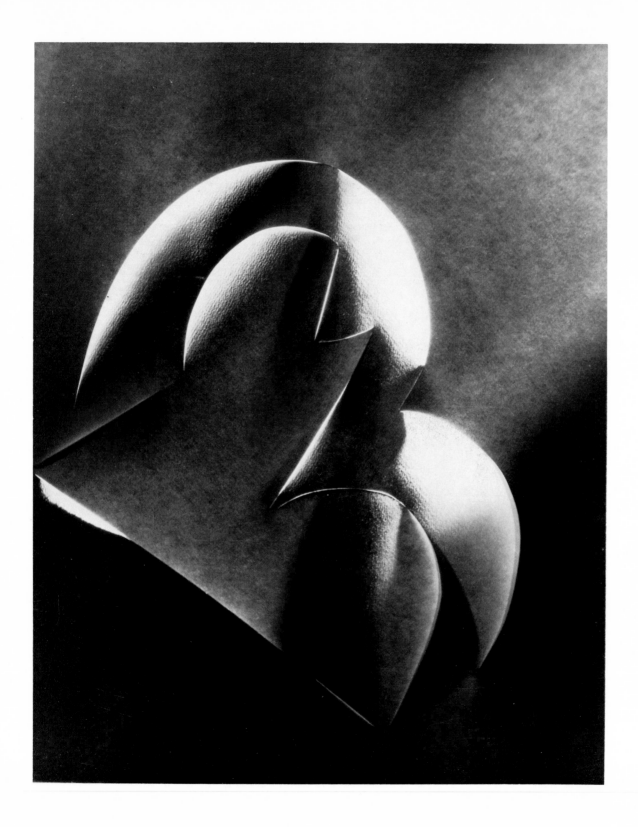

57 and 58 From *Beyond This Point*, 1929

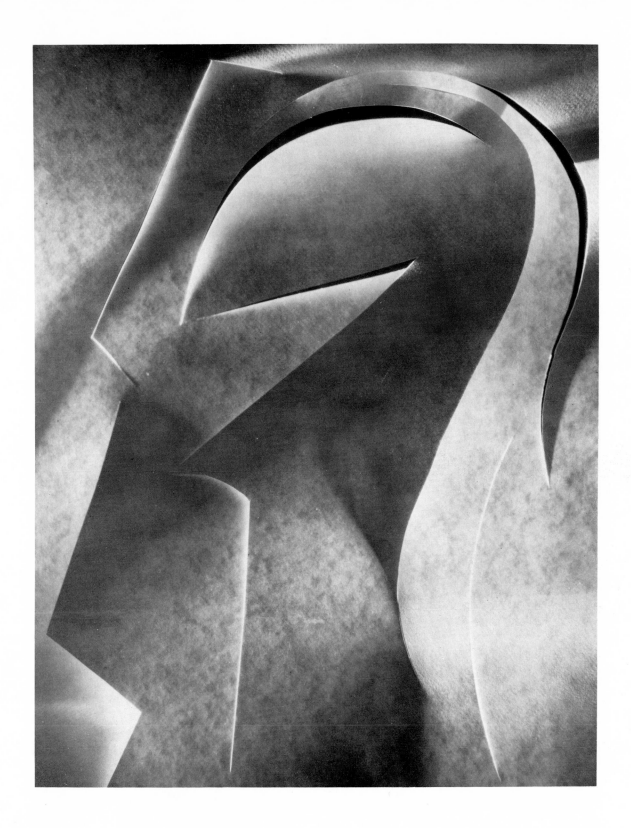

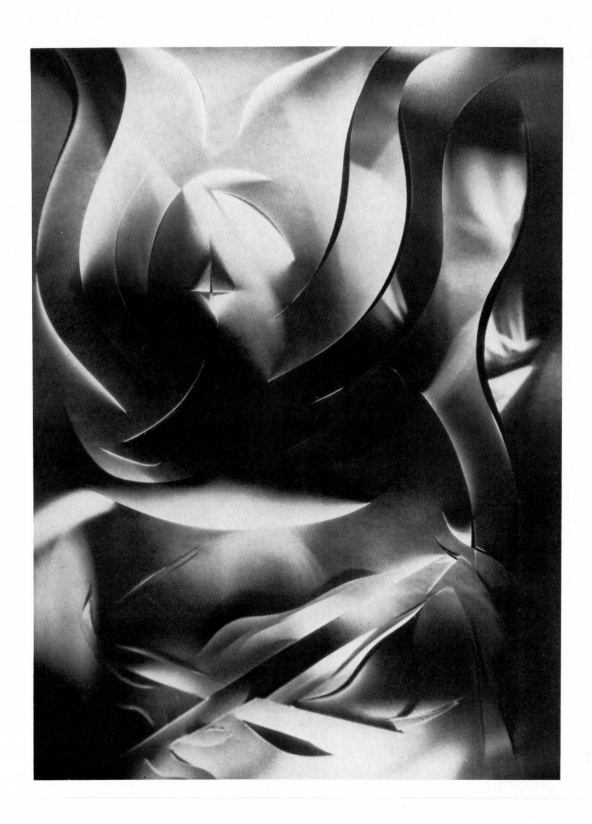

59 From *Few Are Chosen*, 1931

A few months after the book was issued, Bruguière exhibited these photographs along with "various designs" and a selection from *The Way* at the Warren Gallery in London.[51] Two years later, in 1931, Bruguière and Oswell Blakeston collaborated on a similar book, *Few Are Chosen*, but the most significant co-effort of Bruguière's career took place in 1930, when he and Blakeston made England's first abstract film, *Light Rhythms*.

The film was based on a series of light abstractions by Bruguière; Blakeston supplied technical expertise in editing and camera operation. In addition, a friend of Blakeston's, Jack Ellit, was commissioned to compose an original piano score to accompany the film.[52] After its initial showing in London, the film was sent on tour to Europe and during World War II was stored in a vault of a London publishing firm. The building was bombed and the film was thought to have been lost until recently, when a partial negative and the original positive which toured Europe were found.[53] The film was never shown in America.

It would be impossible to reproduce in a book the essence of *Light Rhythms* in static form, were it not for an ingenious system worked out by Bruguière and "Mercurius," author of an article on the film in the March 1930 issue of *Architectural Review*. The film involved approximately thirty different forms which Bruguière photographed as still images; with careful sequencing, the very same images were arranged in the article to give an amazingly accurate impression of the film. Because of the success of the *Architectural Review* article in re-creating that illusion, both the text and the system of reproduction have been repeated here. (Several of the negatives for the original *Architectural Review* article no longer exist. Therefore, in order to maintain accuracy and the intent of the article, blank spaces have been left where negatives are missing.)

Mr. Bruguière's film "Light Rhythms," made in collaboration with Mr. Oswell Blakeston, is a departure from previous film practice in that it receives its animation from the movement of light on static form, and not from the movement of form in static light. As in Mr. Bruguière's still photography the light acquires significance from its impact with the varied planes of form. Form here reveals the light, and the substance and reason of the film lies in the rhythmic pattern of this changing revelation.

The same form is not used throughout the film. Beginning with a simple fundamental curve, the design is developed through vari-

ous degrees of complexity. Following a reasoned sequence, forms arise, mix, fade out, and others take their place. But each form, or combination of forms, as we see them before us on the screen, is static for the time we see them. This is no more than the change of one thing to another in the sense that we see first the one and then the other. The cinematic character of this film lies in the movement of the light, in the constant change of the manner of its revelation.

This may be more easily understood by reference to the illustrations reproduced below, reading them in conjunction with the Light Movement Score shown at the bottom of the opposite page. Each of the five "movements" contains six forms, or combination of forms. Taking movement 1 for the purpose of illustration, the film opens with the simple curve (a1). This form, remaining static on the screen for about ten seconds, reveals the light as it moves in the directions shown by the arrows in the Light Movement Score, Movement 1 (a1). A new form (a2) is then combined with the original form (a1). This combination remains static on the screen for a further period of about ten seconds and reveals the light in its passage indicated by the arrows in the Light Movement Score, Movement 1 (a1, a2). The form (a1) then fades out leaving the form (a2) static on the screen for, approximately, another ten seconds, whilst the light is revealed in its course shown by the arrows in the Light Movement Score, Movement 1 (a2). This sequence of forms, or combination of forms, each in its turn static whilst we see it on the screen and each, in its turn, revealing the light as it moves in the directions shown by the arrows below the corresponding notation in the Light Movement Score, is continued to the conclusion of the film. The movements, or combination of movements, of the light, shown by the arrows in the Light Movement Score, proceed, in general, in a sequence of simplicity or complexity correlated to the simplicity or complexity of the corresponding forms by which the light is revealed.

The exhibition of the film occupies about five minutes.

The musical score, composed by Mr. J. Ellit, is to be regarded as an accompaniment rather than as a synchronization. In other words, it follows the movement of the film in spirit rather than in fact.

The full musical score contains six themes to each movement of film. Three principal themes from each movement are reproduced below the illustrations of the forms to which they are an ac-

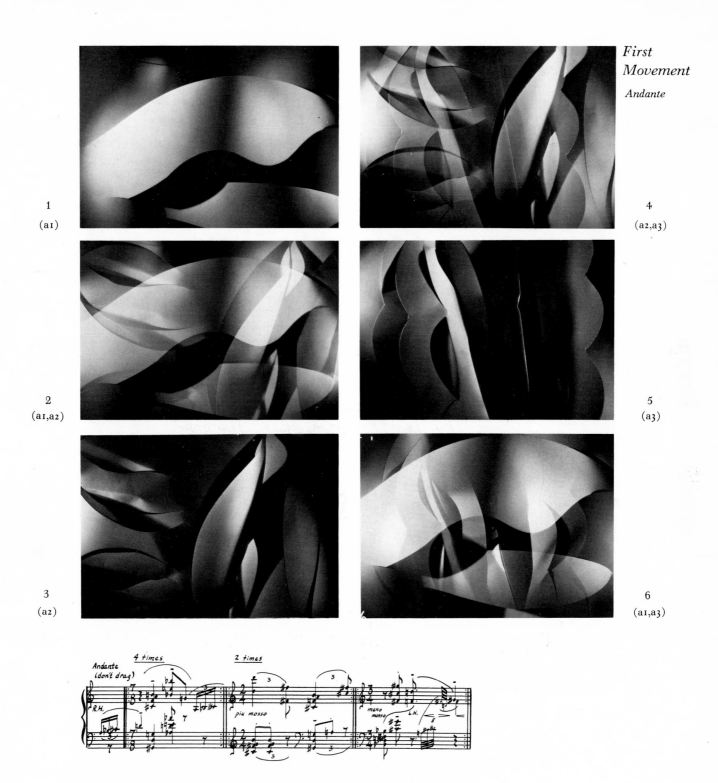

First
Movement
Andante

1
(a1)

4
(a2,a3)

2
(a1,a2)

5
(a3)

3
(a2)

6
(a1,a3)

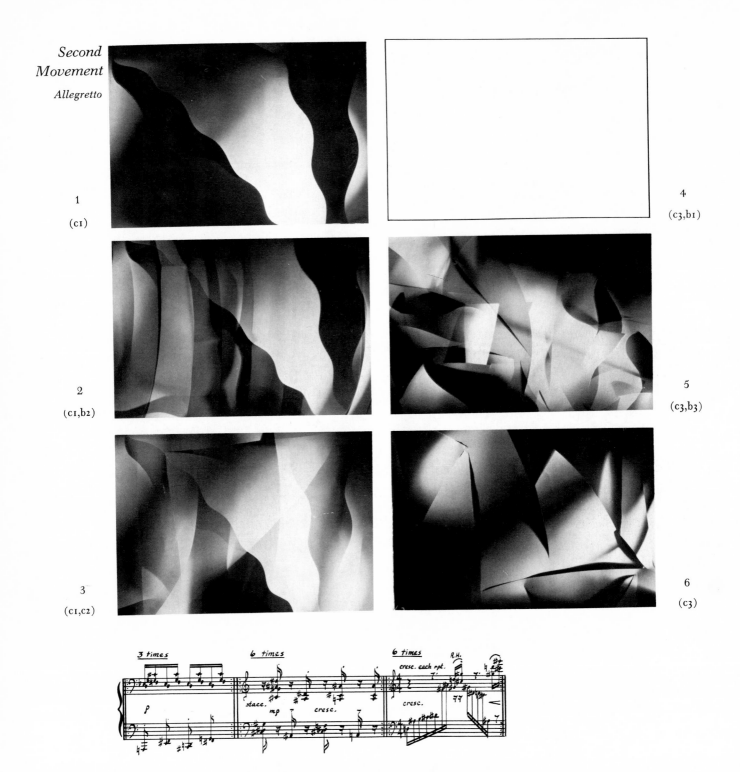

61 and 62 From *Light Rhythms,* 1930

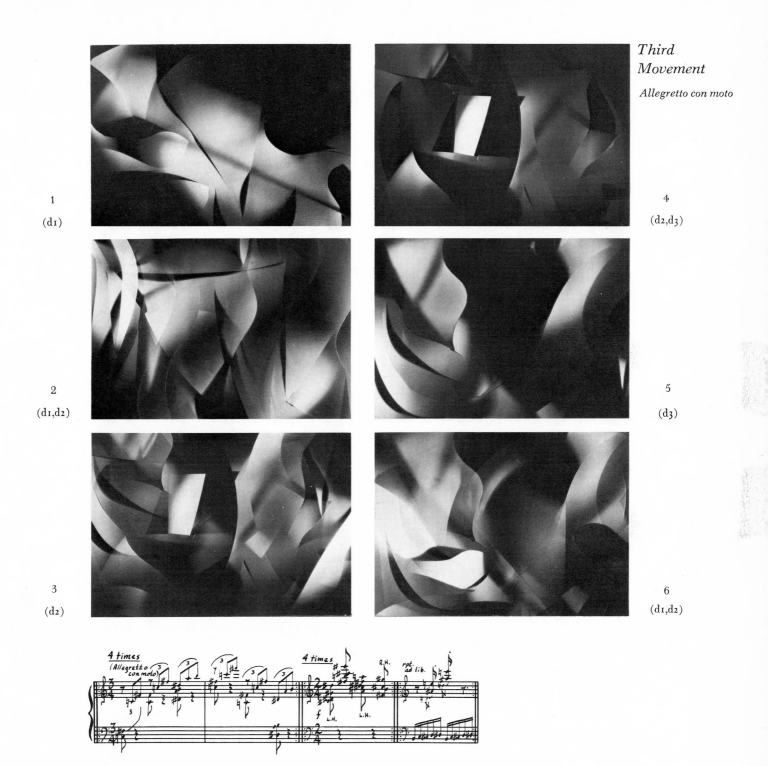

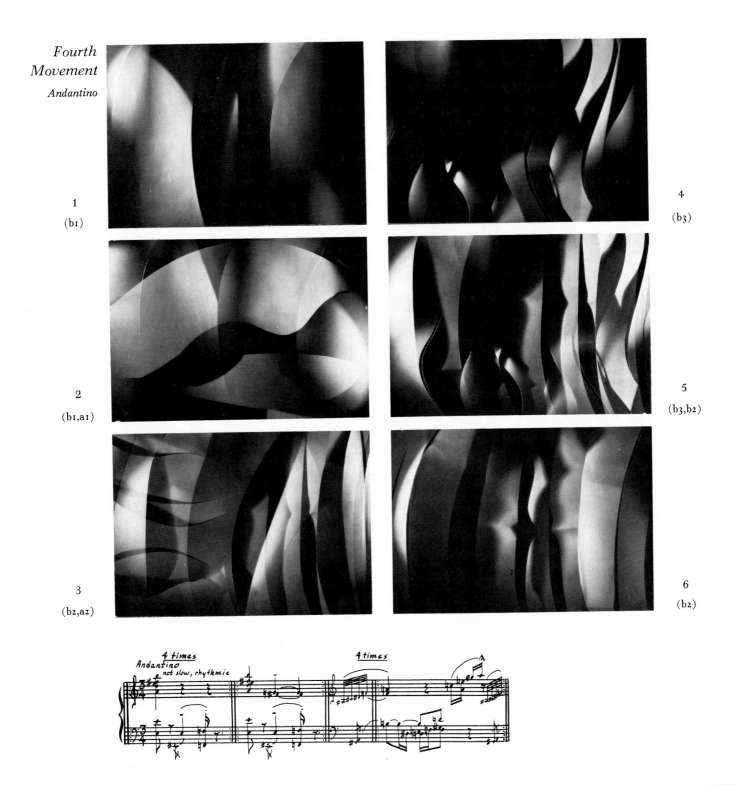

63 and 64 From *Light Rhythms*, 1930

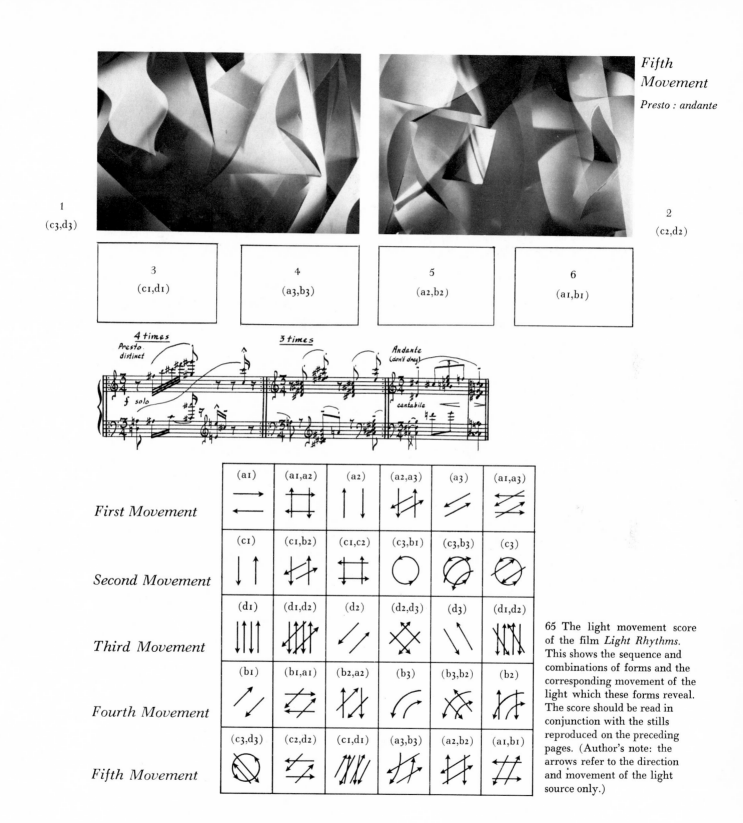

Fifth Movement

Presto : andante

1
(c3,d3)

2
(c2,d2)

3
(c1,d1)

4
(a3,b3)

5
(a2,b2)

6
(a1,b1)

65 The light movement score of the film *Light Rhythms*. This shows the sequence and combinations of forms and the corresponding movement of the light which these forms reveal. The score should be read in conjunction with the stills reproduced on the preceding pages. (Author's note: the arrows refer to the direction and movement of the light source only.)

91

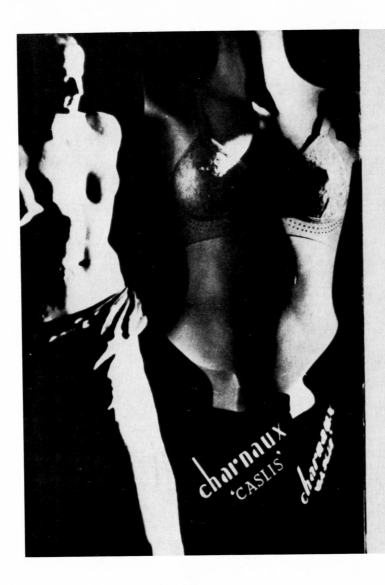

AS YOU LOOK through these pages you will find that we have set out to tell you fairly what Charnaux Belts can do, to show you by photographs, striking in their accuracy and simplicity, exactly what they are.

Charnaux Belts are created from **electrically deposited Latex**, a new material with unrivalled capacity for stretch and returning to shape; they can be washed and dried **in a few minutes**; they are cool, light and exquisite to wear. **The Latex** has thousands of perforations graduated in size and **scientifically arranged** to produce bands of force. These bands **of force are designed to give** not only upward support to the figure but also **freedom of movement**; they incite the abdominal muscles to do their normal work more efficiently and by promoting **their activity reduce fatigue.** The thousands of perforations obviously allow the skin to transpire unimpeded.

Charnaux Belts are beautiful in themselves; they will add to the beauty of your figure, and they will give you the attraction of an 'uncorsetted' look and the smooth lines which have made Charnaux enthusiasts of so many dress designers.

companiment. The tempo of the musical score should also be read as the tempo of the movement of the light.

The first exhibition of this film was given at the Shaftsbury Avenue Pavilion by Mr. Stuart Davis, to whom we are constantly indebted for opportunities of studying so much that is vital and significant in the development of cinematic art.[54] [Plates 60–65.]

Light Rhythms was the only complete film Bruguière ever made, although he did work with Blakeston on a few subsequent commercial films. In one such film, *Empire Buyers Are Empire Builders*, the entire title was formed gradually by streaks of light against a moving abstract background. The importance of *Light Rhythms* is in relation not to the earlier experimental films of Man Ray or Hans Richter, but to Bruguière's expansion of his own abstract imagery. For nearly a decade, light abstractions had been Bruguière's main concern. He had created form with light alone, introduced cut-paper shapes to emphasize the sculptural qualities of the light forms, and finally, with *Light Rhythms*, had accomplished his desire to apprehend the "fourth dimension" by creating the "effect of movement . . . though the object itself was absolutely stationary." *Light Rhythms* represented for Bruguière the ultimate achievement of his light-abstraction works. From 1934 until his death, he continued to experiment vigorously, but in new and different areas unrelated to his light imagery.

It was at the beginning of this period (1933) that Bruguière met E. McKnight Kauffer, an American who spent most of his working life in London—1915 to 1940.[55] It was a coincidence of fate that although he and Bruguière did not know each other in 1921, Kauffer too had worked a short period for the Theatre Guild in New York.[56] It was Kauffer who in 1934 introduced Bruguière to the advertising world in London. As art director of Lund, Humphries Ltd., an advertising firm, Kauffer was in a position to help fellow artists and collaborated on posters and advertisements with, among others, Bruguière, Man Ray, and Jan Tschichold.[57] Both Man Ray and Bruguière worked with Kauffer on advertisements for the Charnaux Corset Company (Plates 66–67).

In his last use of cut-paper abstractions and light imagery, Bruguière created a series of advertisements for Shell Oil and the British Postal Service (Plates 68–69). Bruguière's interest in the advertising world during this time did not represent his return to commercial photography in the strict sense of the word. Rather, because of the respect he held for Kauffer, who struggled to upgrade design in the commercial world,

Bruguière saw his participation as a new challenge for photography. He maintained that his photographs used in advertisements were not illustrative, but acted as catalysts "to start something."[58] He had always manifested an interest in the visual pleasure that could be drawn from pure design alone, and the fact that such design could be put to utilitarian purposes only enlarged the communicative potential of photography.

In a few instances, Bruguière and Kauffer collaborated to make noncommercial photographs, which compositionally relied upon Kauffer's cubist format. One was used on the cover of the brochure for their joint exhibition at the Lund, Humphries Galleries in 1934 (Plate 70). During his association with Kauffer, Bruguière created a series of these images, which were stylistically different from any of his earlier work. They were graphic and collage-like, combining superimposition and juxtaposition of real objects with two-dimensional drawn or painted works (Plates 71–74). Although there are only a few of these collage-like photographs in existence, they are extremely important as transitional works, representing a shift in Bruguière's imagery from abstractions based on an inner awareness to abstractions of the physical world. This change of direction reflected Bruguière's obsession with the conscious as well as the unconscious, and his drive to test and expand photography's expressive potential. His paintings during this period changed also. Like the "collage" photographs, they became flattened abstractions of real objects based on compositional elements that were inspired by cubism and Kauffer (Plate 75).

The early thirties were a period of general reevaluation for Bruguière. In 1932 he and Rosalinde Fuller returned to New York for a visit. On this trip Bruguière began a collection of photographs for a new film. He and Norman Bel Geddes had planned to make a series of short films on New York, but the Depression brought an abrupt end to their plans.[59] It was to be, as Bruguière called it, a "pseudomorphic film." In a technical sense the photographs were not manipulated, yet through the intentional distortion of an upward camera angle, and with the use of large geometric shapes in the foreground, they are as abstract and subjective as any of his works.

One of these images, a view of the Murray Hill Hotel's spiral staircase (Plate 77), has a virtual twin in the work of another great American photographer. In 1935, three years after Bruguière, Berenice Abbott photographed the same building as part of her *Changing New York* series. Both the camera angle and the composition of the two photographs are nearly identical.[60] Abbott's approach to New York in 1935

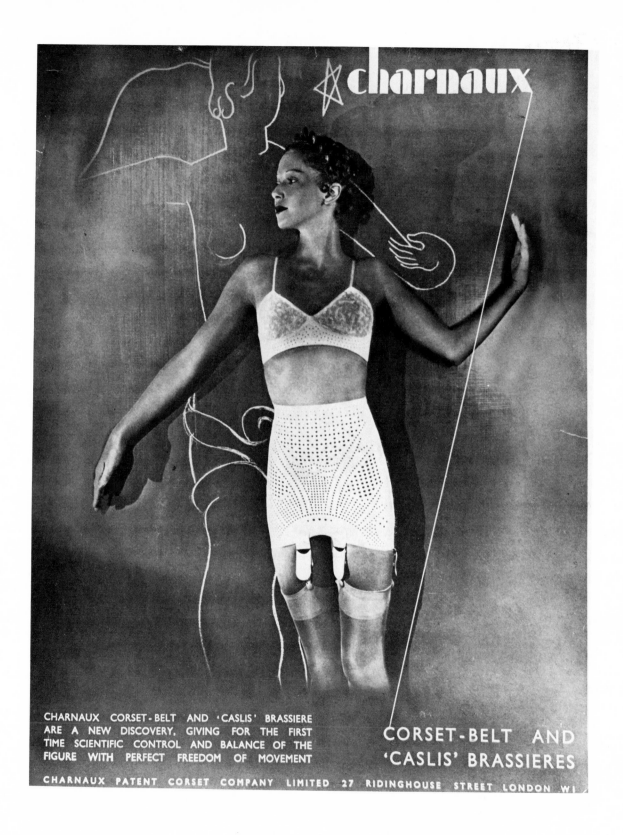

67 Advertisement by E. McKnight Kauffer and Bruguière, c. 1932

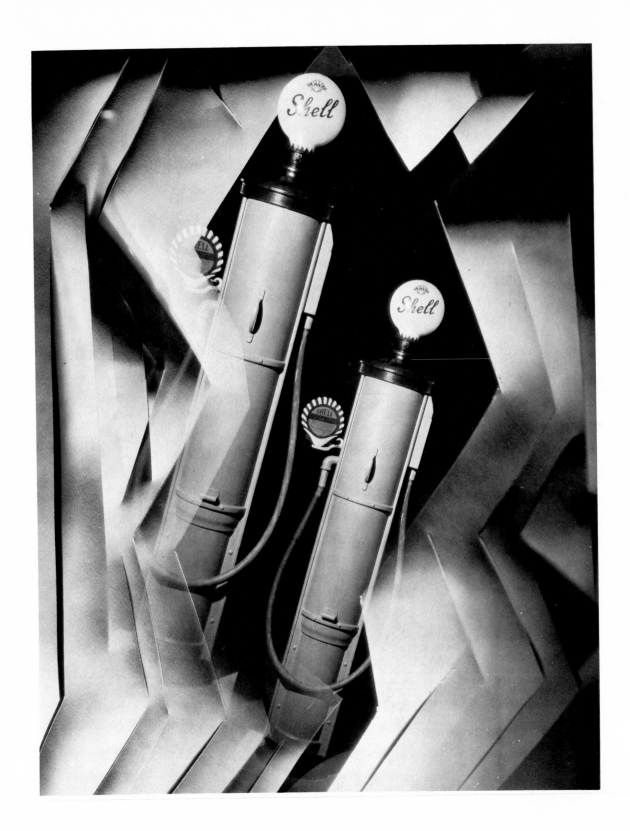

68 Advertisement for Shell Oil Company by Bruguière, c. 1934

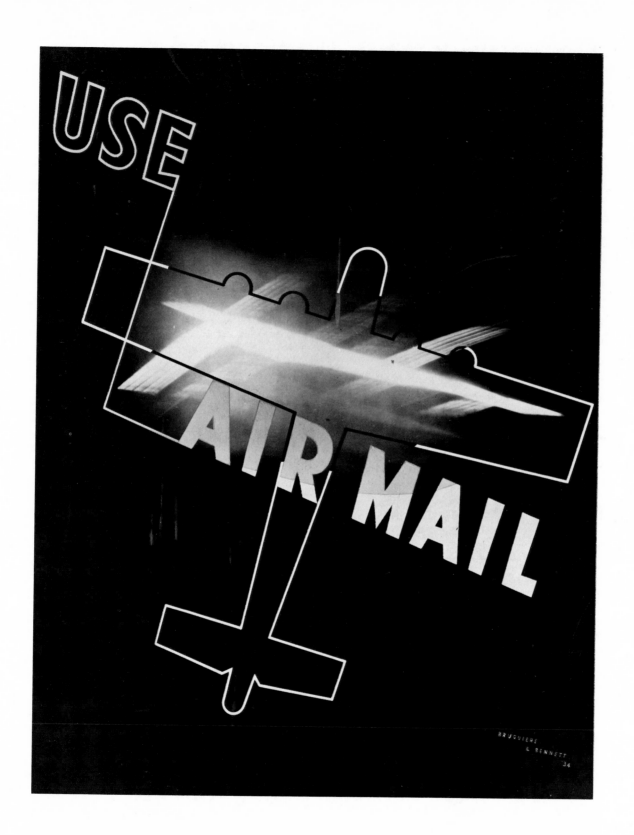

69 Advertisement for British Postal Service by Bruguière and Bennett, 1934

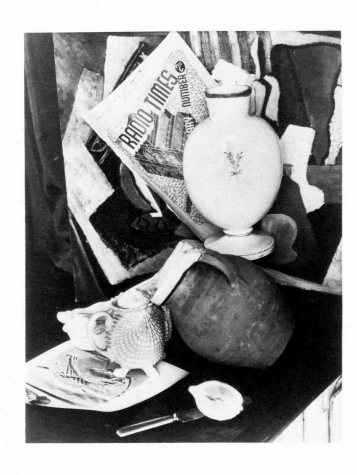

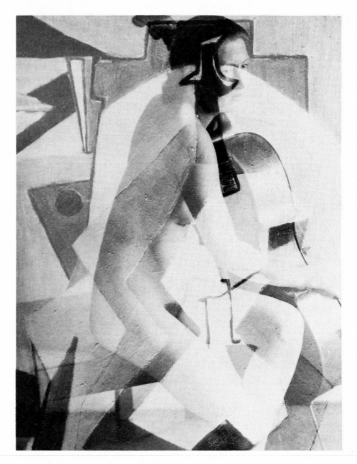

70 Cover for exhibition catalogue by Bruguière and E. McKnight Kauffer, 1934

71 Multiple exposure, c. 1934–35

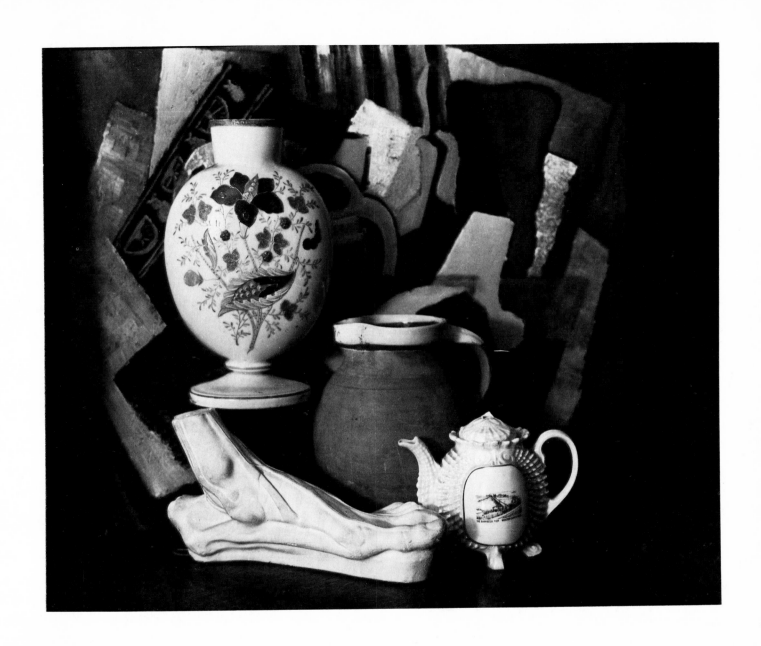

72 Still life, c. 1934–35

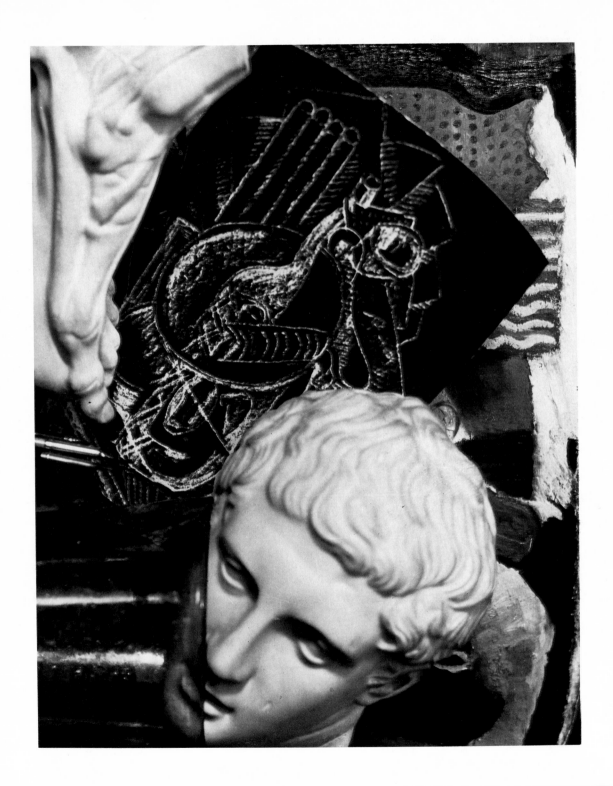

73 and 74 Still life, c. 1934–35

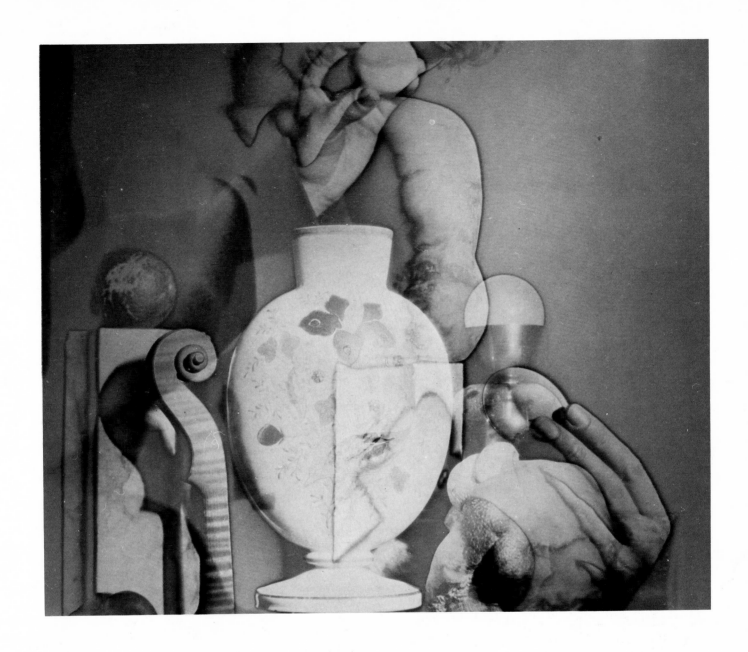

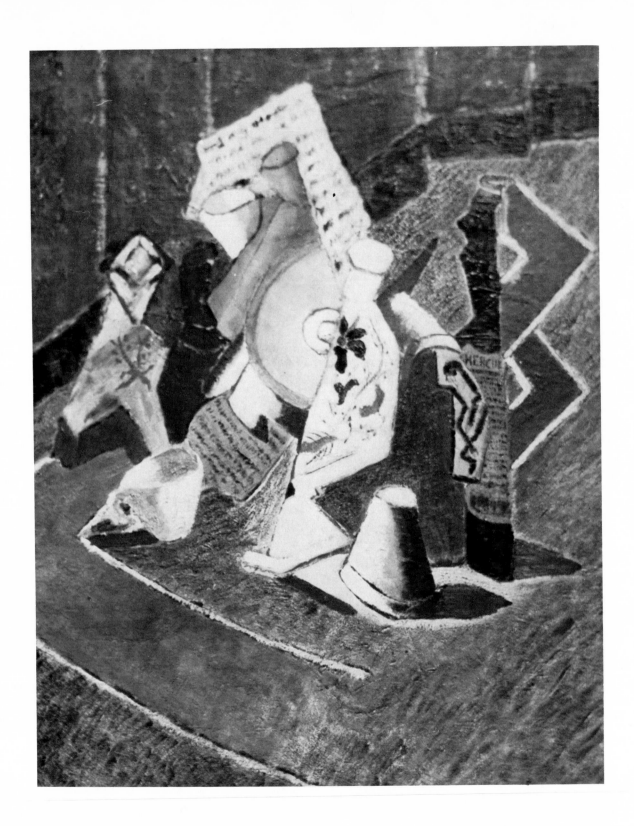

75 Painting by Bruguière, c. 1935

was primarily documentary, based on the principles of a "straight" aesthetic. When, in 1932, Bruguière had photographed New York, he had returned to those same principles—not to document the face of the city, but rather to photograph what he saw as its pseudo spirit. With both Abbott and Bruguière, the motivation was clearly not simple sociological documentation, but an attempt to evoke the spirit of the city as they saw it. Interestingly enough, although their basic insights may have differed, they responded alike to a given situation: the abstract qualities inherent in the scale, contrasts, and patterns of the skyscraper and its environment.

Several years of living in the relaxed atmosphere of England had cultivated in Bruguière a distaste for the social ills of the city he thought he remembered so well. New York architecture, particularly the skyscrapers, was for him a symbol of the city at its best; yet when he visited them, the buildings seemed false in their symbolic promise of change; they were "pseudomorphic" (Plate 76).

In 1933, *Close Up* reproduced a selection of these photographs, with comments by Bruguière:

> West Side of New York—isn't this the city which Russia dreams about? Garbage cans taking wings with escaping paper-filth and kids playing among the tissues of smells. . . . the Empire State Building, which was built to take 80,000 people, has only 300 tenants. Silent City of the Air! . . . Interior lighting, to match the world depression, is universally amber! . . . From the Plaza stretches Central Park. Its stunted trees and rock-grown grass are generally covered with the 365 pages of the Sunday newspaper.
>
> In a rush now—because this pseudomorphic film is outrunning its footage. . . . Anyway, I feel that skyscrapers are only successful when they are not architecture, when they have no Renaissance tops.[61]

Prior to his New York trip, Bruguière had photographed the cathedrals of England in the style he used for his "pseudomorphic" film. These pictures, exhibited at the Warren Gallery in London in 1931, were part of his search for a new photographic expression. As in his "pseudomorphic" images, the cathedral photographs were both "straight" and multiple exposures. An interesting aspect of the multiple-exposed photographs was that the complete image was composed in the camera and did not rely on later superimposition, cropping, or related

darkroom techniques. This concept is, of course, integral to the straight aesthetic which Bruguière had mastered during the early part of this century. In borrowing from one aesthetic (straight) to accomplish another (abstraction), Bruguière was, as always, pushing his medium to the very brink of its potential (Plates 78–83).

Unlike the "pseudomorphic" images, the cathedral photographs were not equivalents or of a symbolic nature. They were studies in pure design. There is also evident in them a sense of nostalgia for his first works, especially the straight, unmanipulated cathedral interiors.

It may seem curious that Bruguière should choose to investigate an aesthetic style that already had strong precedents, ten years earlier, in the works of Steichen, Strand, Sheeler, and others. However, when these photographers had been experimenting with the straight aesthetic, Bruguière had been engrossed in his surrealist and light-abstraction works. Since he had never felt the need to be identified with a movement or trend (after 1919), he placed little value on the chronological sequence of aesthetic developments. In making the cathedral photographs, he had returned to an earlier process to solve its problems for himself, and according to his own imagery.

In 1937 Bruguière was commissioned to design, with architect Oliver Hill, the entrance to the British Pavilion at the Paris Exposition. Fifty-foot-high curved walls were covered with photomurals of scenic and industrial England. The murals were made with a new process used for the first time on such a considerable scale: large sheets of plywood, up to twenty feet in length, were sensitized with a light-sensitive plastic paint and the photographs enlarged onto them. The negatives for the murals were lent by *The Times*, *Country Life*, and individual photographers (Plates 84–85).

Bruguière was interested in the pavilion project as a designer rather than as a photographer. He had written about the "decorative art" potential of large-scale photographs a few years earlier in *Modern Photography*. This opportunity provided him with a means of testing his idea.

In the last few years, through the perfecting of the enlarging process, photographs have become adaptable to mural decoration. . . . In New York large surfaces of wall are covered by photographs that quite hold their own in interest in relation to paintings on a similar scale. It is possible, by the application of some of the principles I have indicated, to transform the "circumstantial precision" of the

photograph into something quite as creative in mass, line and tone as decorative mural painting.[62]

The pavilion was the last commercial experiment of Bruguière's career. During the war and because of failing health, he moved to the tiny village of Middleton Cheney, in Northamptonshire, where he devoted all his time to painting.[63]

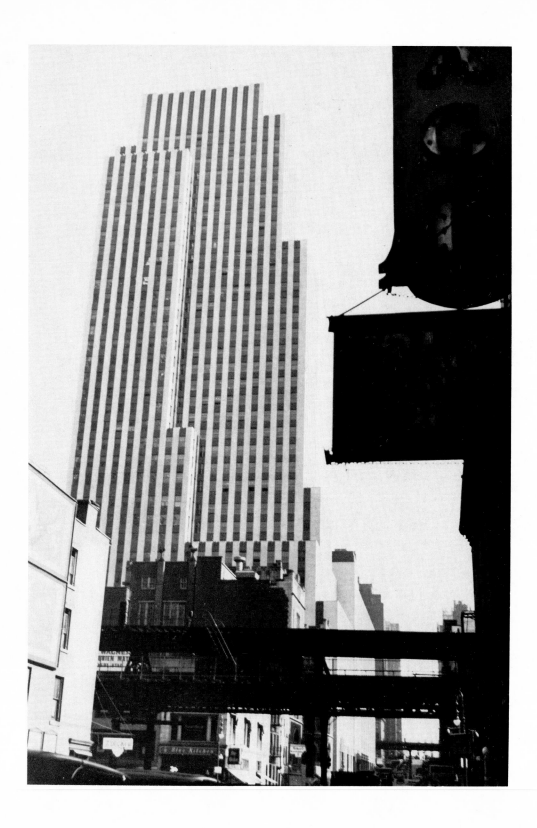

76 and 77 "Pseudomorphic" photographs, 1932

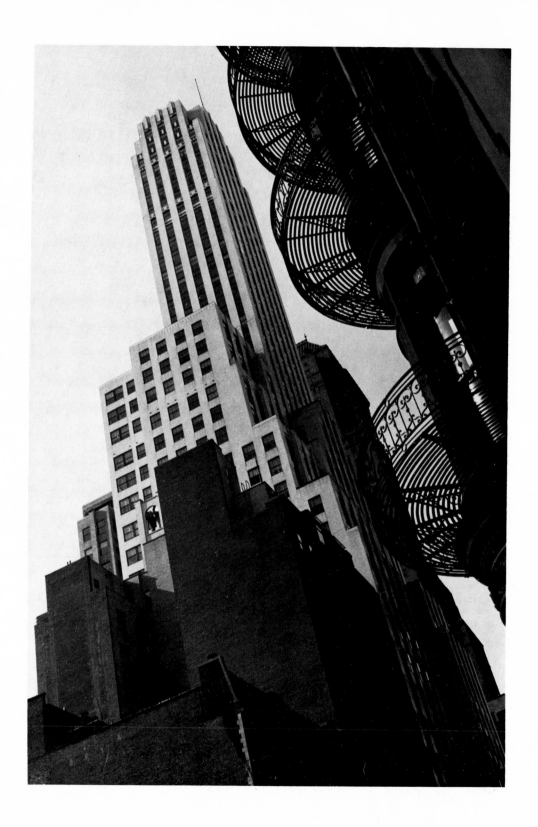

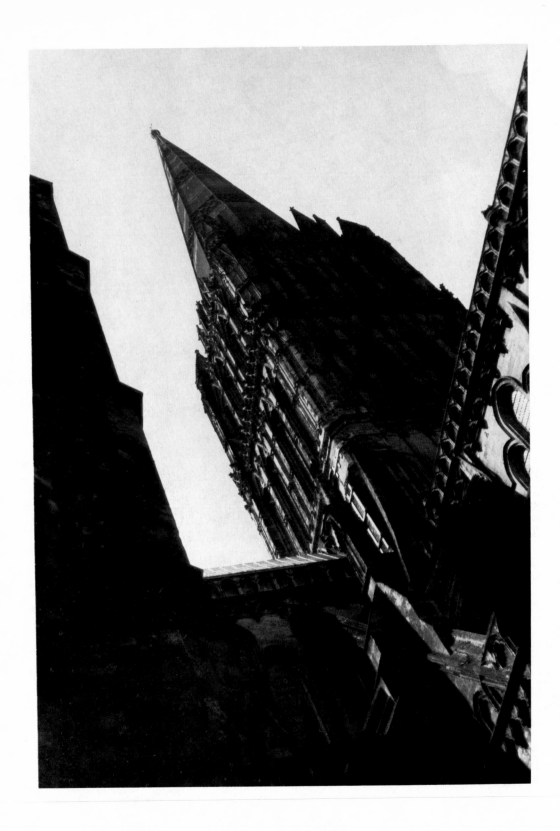

78 and 79 English cathedral abstractions, 1931

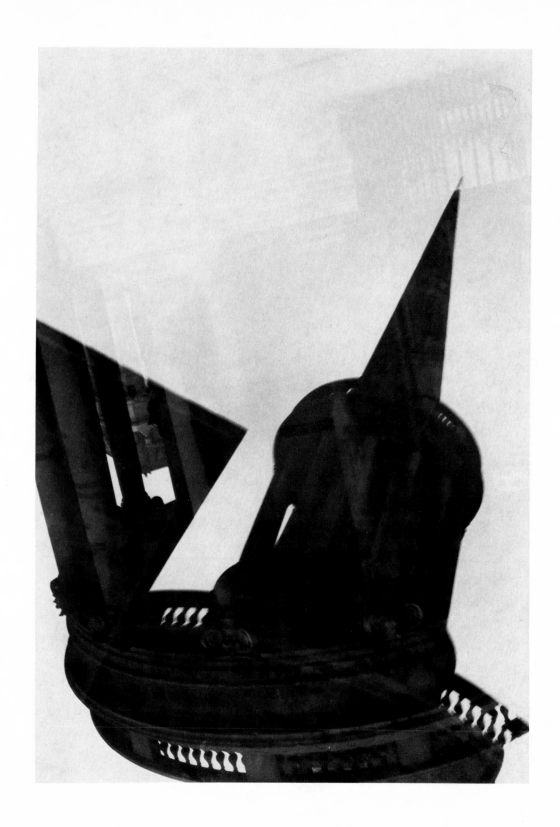

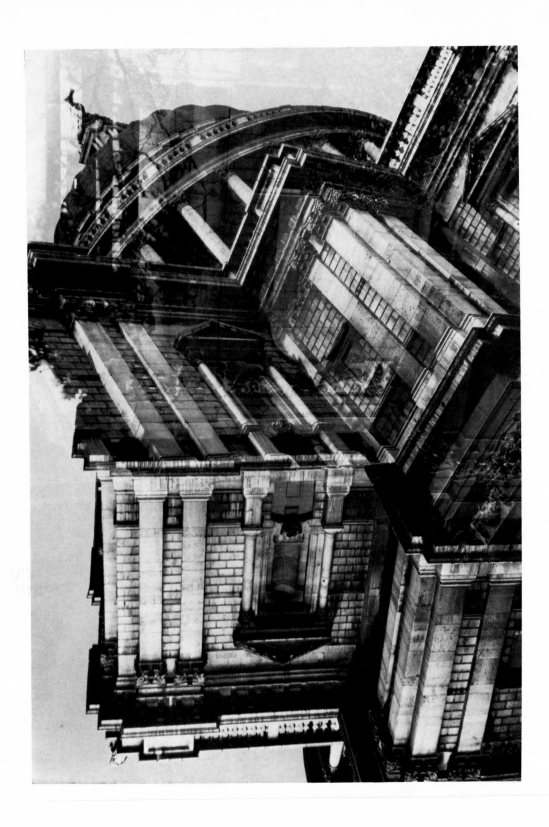

80 and 81 English cathedral abstractions, 1931

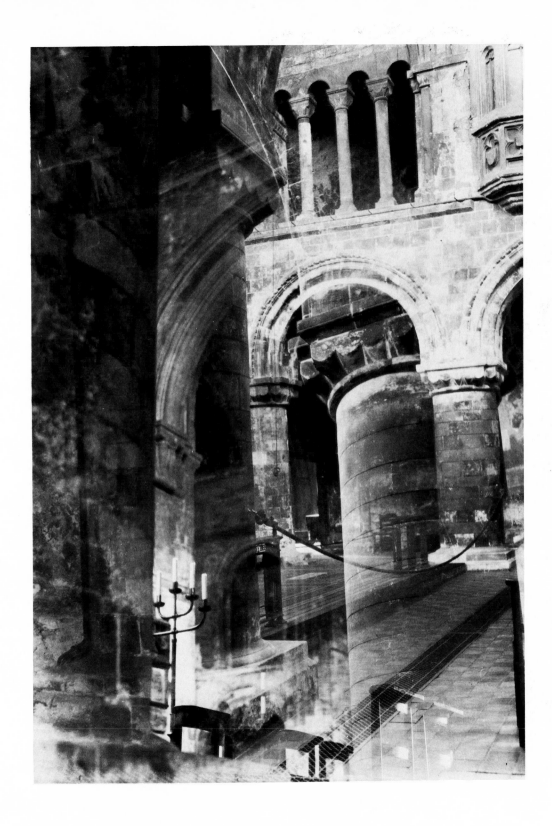

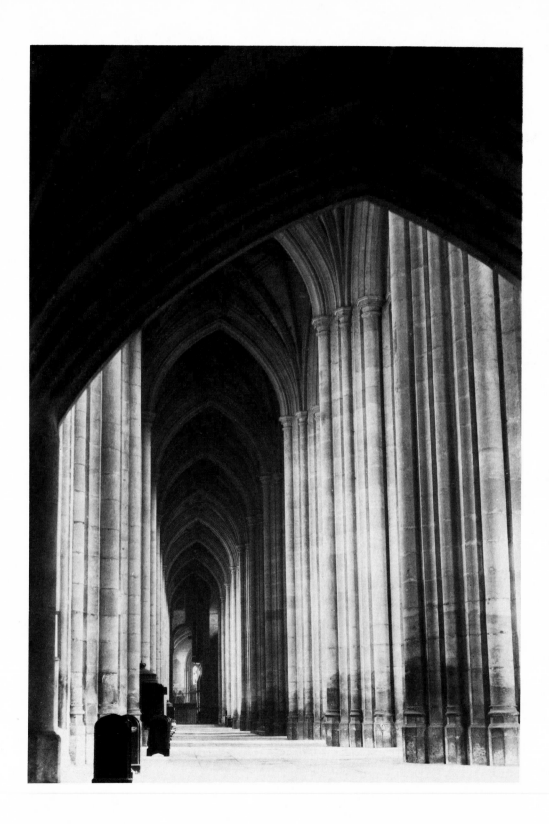

82 and 83 English cathedral interiors, 1931

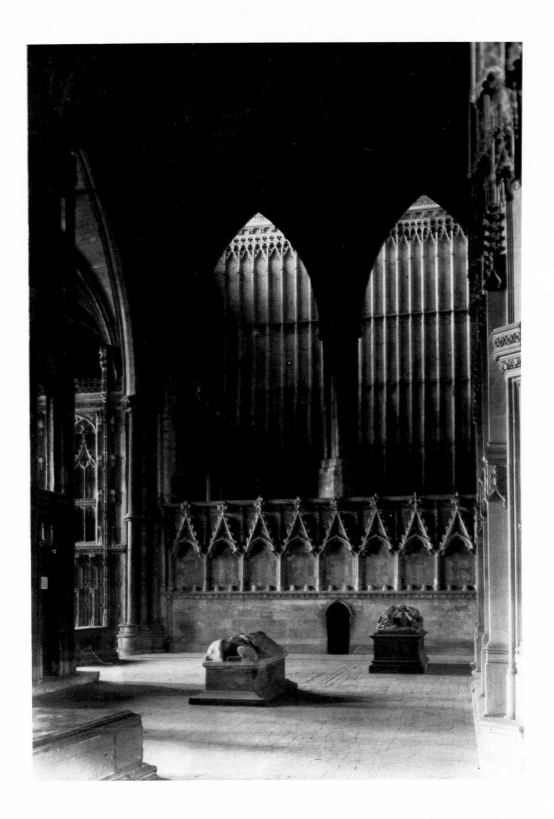

113

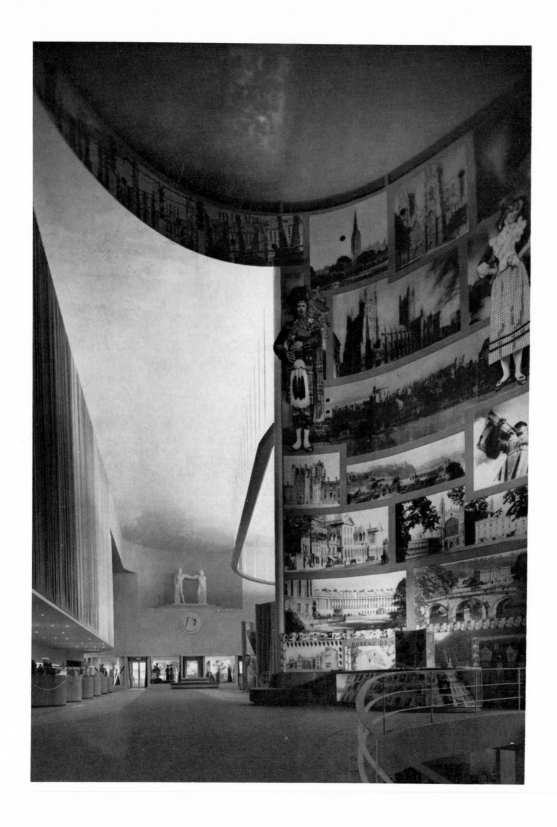

84 and 85 British Pavilion, Paris, 1937

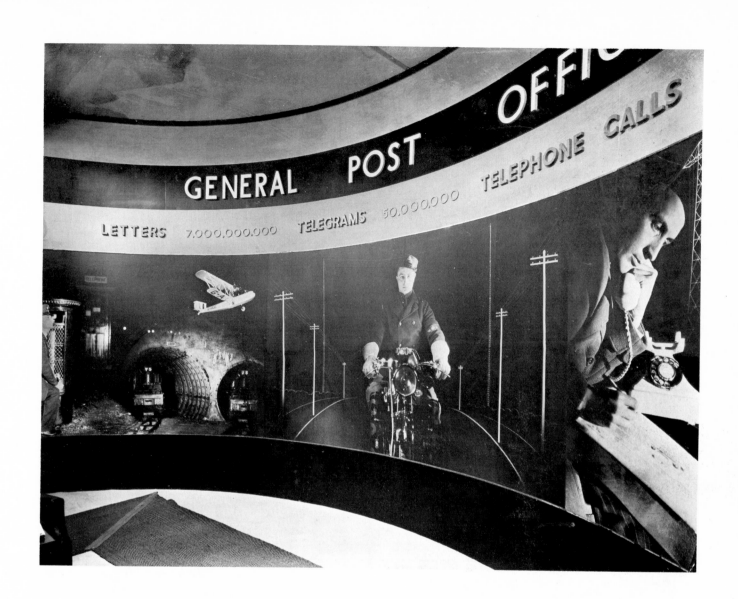

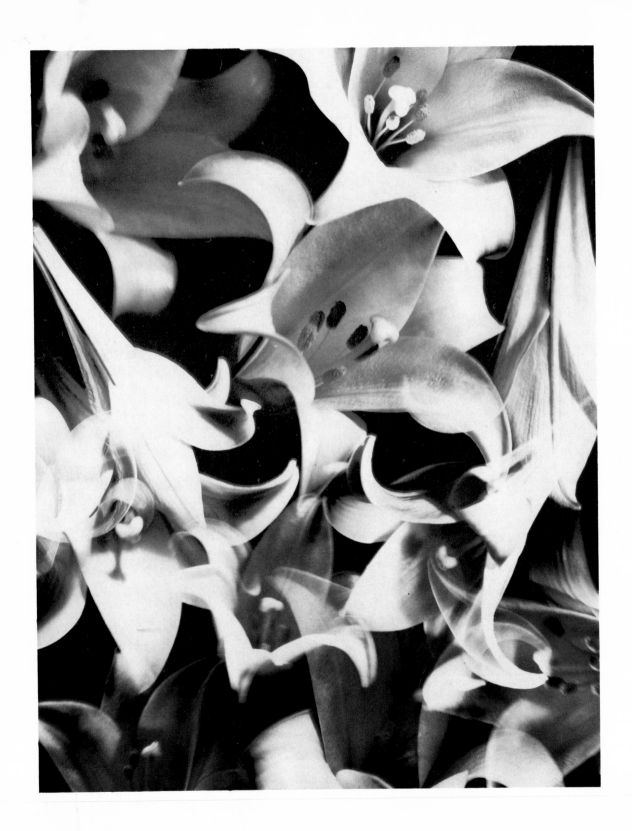

86 Flower abstraction, c. 1936–40

4

Other Experiments
1930–1940

Bruguière's experiments before 1930 were devoted exclusively to prob-
ing the realm of psychologically relevant imagery. Each experiment
was an end in itself and the result was rarely a glorification of form for
visual pleasure alone. During his last working years in London (1930–
1940), Bruguière used a variety of methods (straight, Sabbatier effect,
cliché-verre, relief printing) to expand his own realm of visual pleasure
and to experiment in depth with various processes, especially solariza-
tion. While some of these images resemble his earlier work in their sur-
realistic feeling or abstract format, it is apparent that his main concern
was the control of shape and tone, any additional meaning being sec-
ondary. For example, using straight and multiple-exposure methods, he
abstracted objects from the real world: close-ups of flowers became near-
abstract designs; man-made objects, photographed in repetition, became
abstract patterns; and by use of natural light, a carefully arranged still
life revealed the graphic character of shadows (Plates 86–91).

Bruguière surrounded himself with those things which he felt contributed to the spirit of his search for inner meaning. Consequently the subjects for most of his photographs during this period were drawn from his personal environment and were either studies of Rosalinde Fuller or of objects from their apartment—flowers, bowls, kitchen utensils, and the rooms themselves. Although Bruguière's fragile health contributed to the closed environment in which his new visual search took place, it should be remembered that even in his early experimental years, the majority of his images were made within his studio with only his closest friends as models.

While each of the later photographs is a new and different experience in abstract form, they all relate compositionally to his earlier multiple exposures of Rosalinde Fuller and Sebastian Droste. A complex pattern of overlapping images, all of the same subject, move in and out of focus. At times, in various parts of the composition, the subject will appear almost complete and uninterrupted, only to be drawn back into abstraction by some slight overlapping or unusual juxtaposition of another object. Even here Bruguière's unusual sensitivity to light is apparent. Each of the objects is defined by dramatic yet obscure light sources, giving it extraordinary dimensional and sculptural qualities (Plates 92–106).

In 1935 Bruguière wrote about a process that most excited him in its potential for contemporary imagery:

> The process which was observed from the beginning of photography termed "solarization" has been technically perfected by Man Ray. It is accomplished by exposing a fully developed negative or print to the light for a few seconds, and then continuing development and fixing. It is, as far as I know, the most promising process in the hands of the modern photographer. . . . The possibilities of the resultant image range from slight to a complete transformation of the photographic image.[64]

In his solarized works, a single master negative would often yield several different versions of the same subject. Each version was a finished work and represented an effort to simplify form and refine the pure design qualities of the image. The subtle surrealistic character of the solarizations was due as much to the process itself as to any particular intent on the part of Bruguière. Through his solarizations, Bruguière transformed the verisimilitude of the traditional silver print into a graphic abstraction. "The photograph," in his own words, "is a species

of graph, representing nature. . . . It is a compromise! At times it seems to be more than nature, at other times less!"[65] In many cases this graphic transformation of reality heightened the evocative powers of the image; conventional portraits evolved into surreal dramas and simple nude studies became erotic interplays of sensual form. Nude subjects, ordinarily recognizable, are changed by solarization to the extent that they are no longer simply nudes. The bodies become graphic abstractions and the mood of each photograph changes according to the degree of abstraction. In Plates 94–98, Bruguière's selection of subjects and his obvious manipulation of the process reveal a controlled emphasis of the solarization for the sake of emotionally or psychologically evocative imagery.

Bruguière's solarizations differ from Man Ray's in that they are essentially more abstract, with a greater emphasis on pattern than on line, and they generally adhere to a lower tonal key. Man Ray's solarizations were usually of positive images, and exploited the unique feature of edge reversal or outlining. Bruguière's solarizations were often of negative images, creating a white outline rather than a black and reversing the normally unchanged tonal values of a positive print. The relationship between the solarizations of Bruguière and Man Ray is of unusual importance because the two men are among the very few artists to experiment with the technique during the thirties. Certainly, photographers today are more acquainted with the process and more apt to take it for granted than their peers of several decades ago.

As he did in the photogram, Man Ray pioneered and perfected the solarization process, and although he began his experiments with the technique before Bruguière, his investigations were no more comprehensive. The majority of Man Ray's solarizations do not go beyond an initial edge reversal. But then Man Ray's interest in photography was, in a sense, more limited or narrow than Bruguière's. Dadaism was the mainstream of concern for Man Ray and photography only a tributary. For Bruguière, photography was a way of life and the ideas of other artists were the tributaries.

The last decade of Bruguière's life was devoted to technical experiments as a means of expanding his imagery. Consistent with his philosophy of art and inner awareness, the more he liberated photography from reality, the more he liberated himself.

Throughout his notes and articles Bruguière expressed a wide knowledge of the history of photography and its processes. It is not surprising, therefore, to find that he also worked with a cliché-verre-like

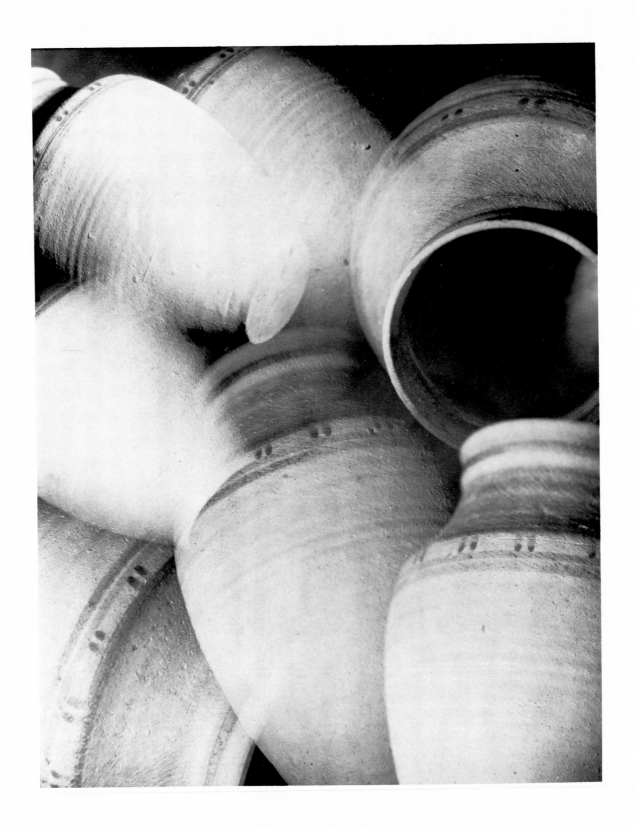

87 and 88 Ceramic pot abstractions, c. 1936–40

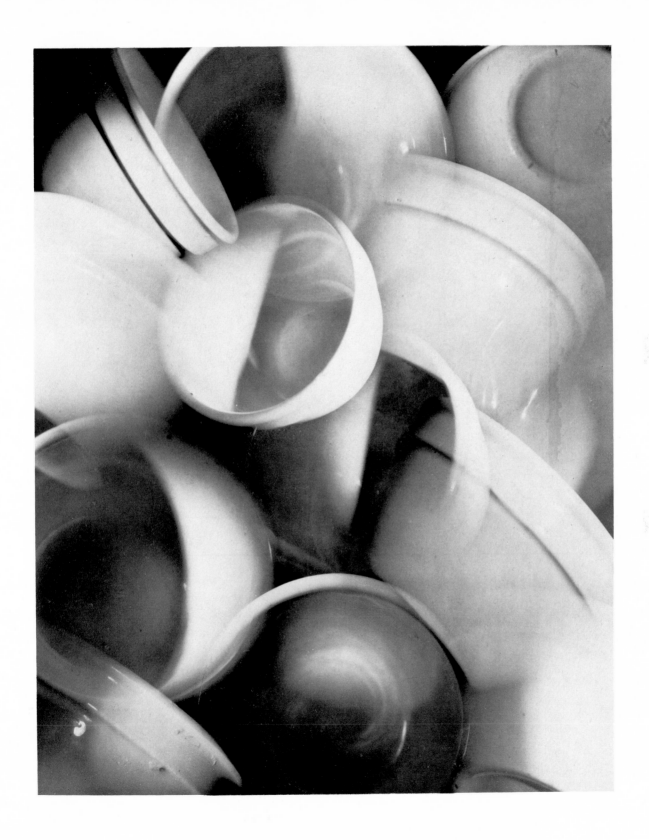

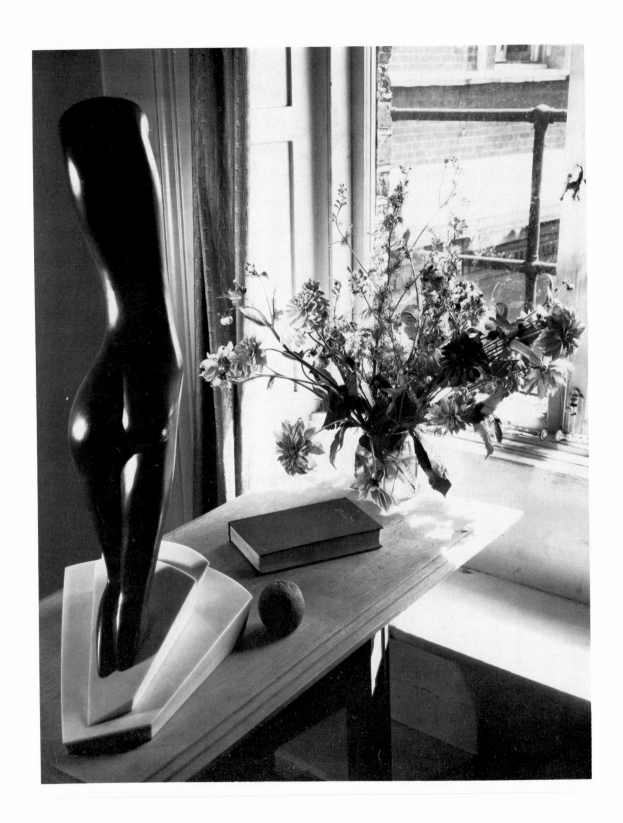

89 Bruguière's apartment, London, c. 1936–40

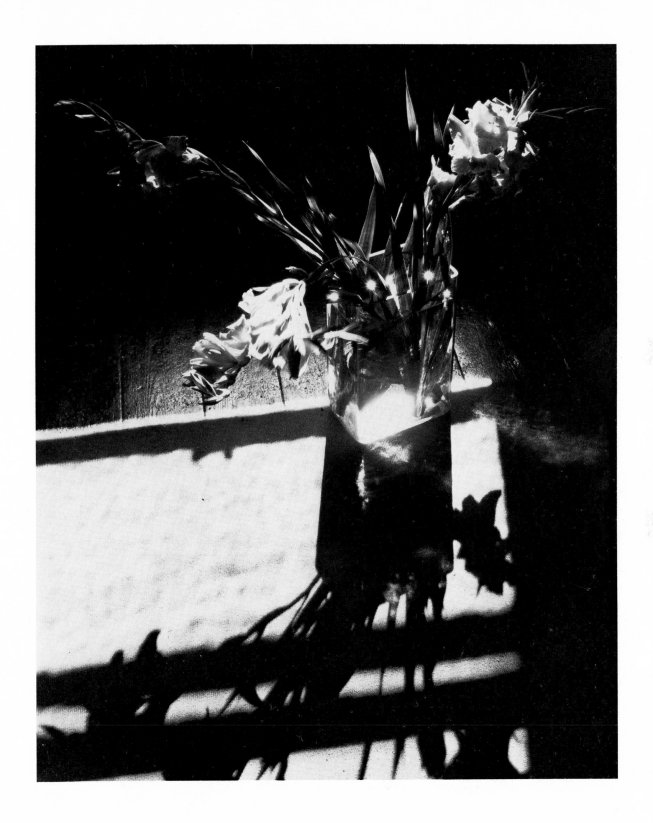

90　Still life, c. 1936–40

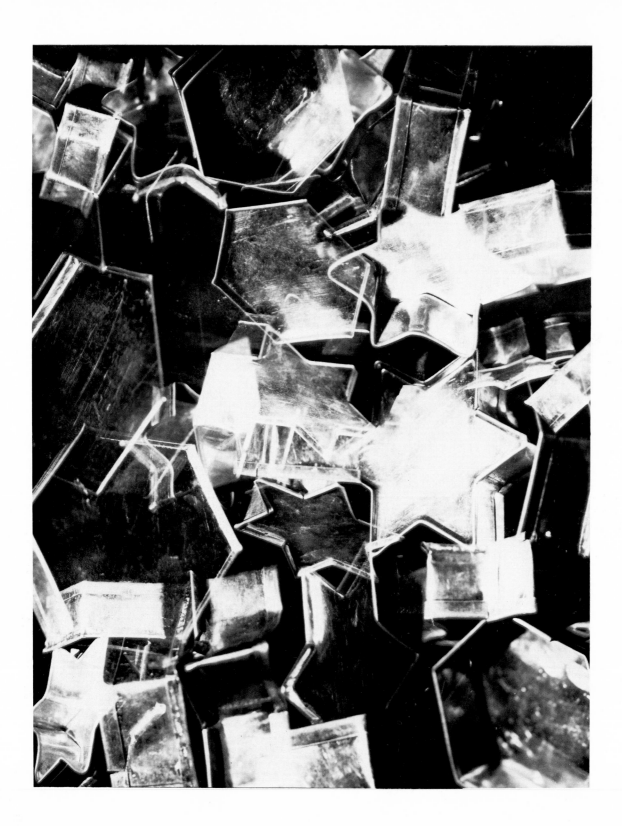

91 Cookie-cutter abstraction, c. 1936–40

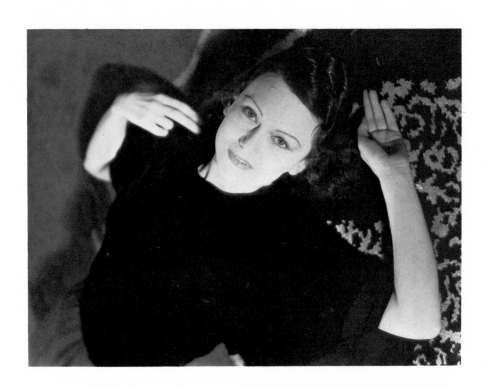

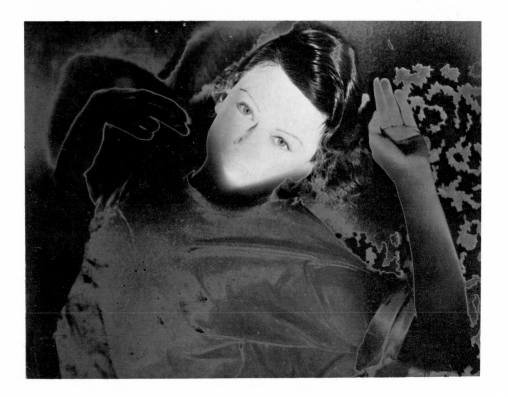

92　Rosalinde Fuller, c. 1935

93　Rosalinde Fuller, another version, c. 1935

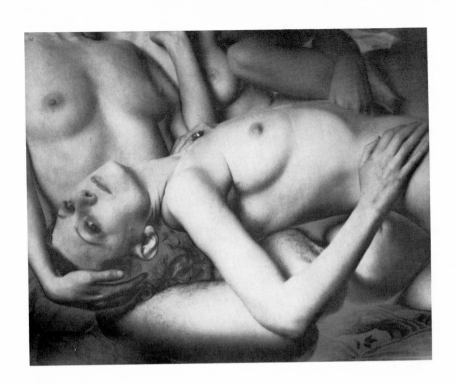

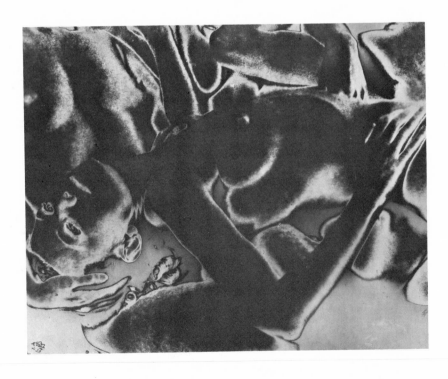

94 Rosalinde Fuller and other models, c. 1936–40

95 Rosalinde Fuller and other models, another version, c. 1936–40

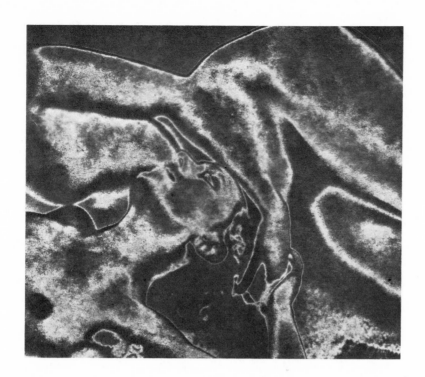

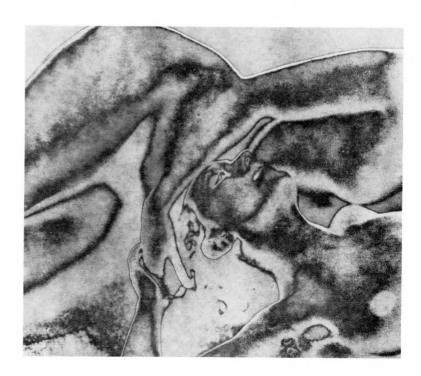

96 and 97 Rosalinde Fuller and other models, two versions, c. 1936–40 127

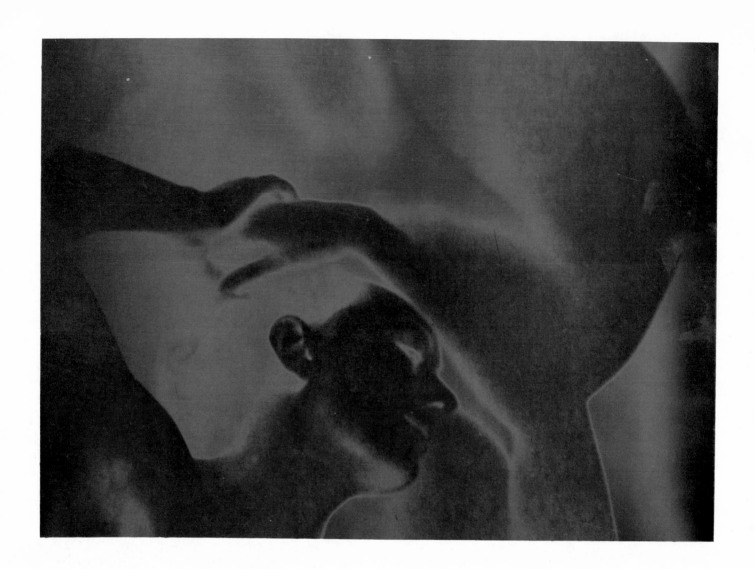

98 Rosalinde Fuller and other models, another version, c. 1936–40

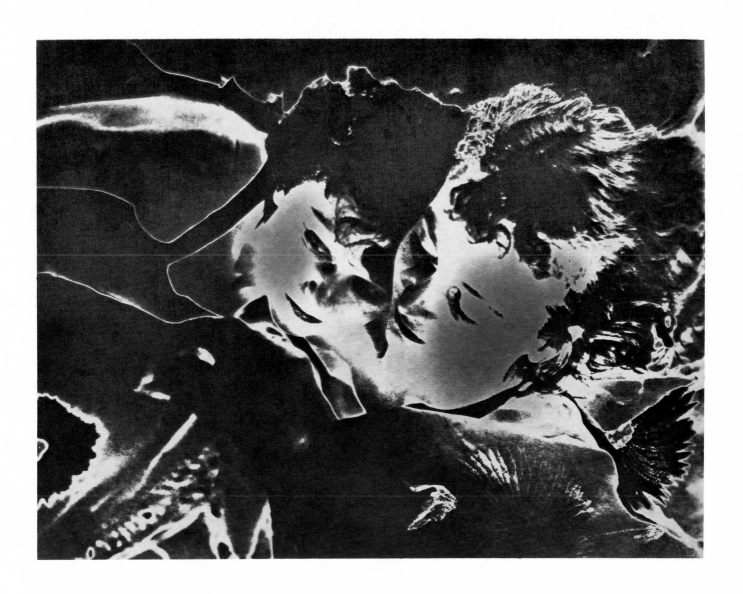

99 Rosalinde Fuller and her sister, c. 1936–40

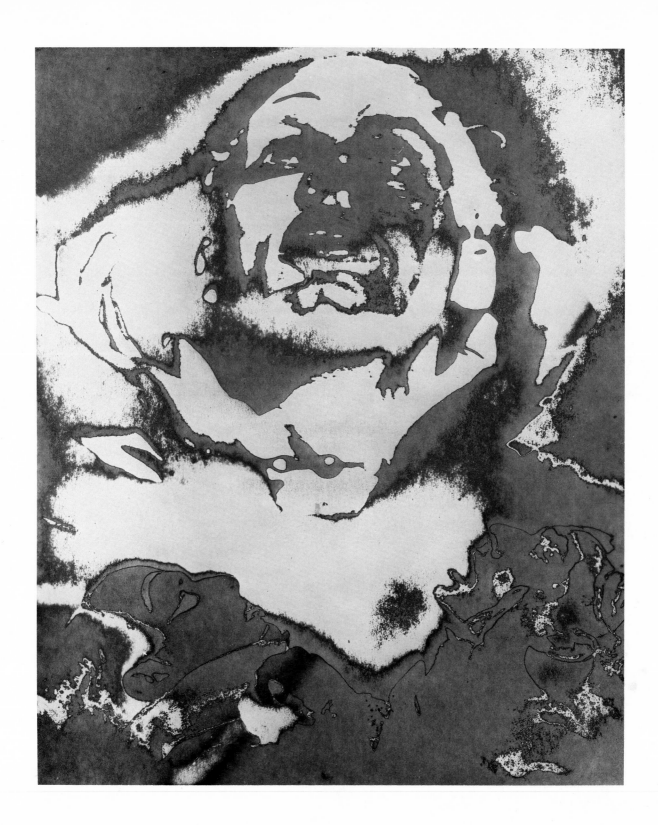

100 Solarization of a negative from *The Way*, c. 1936–40

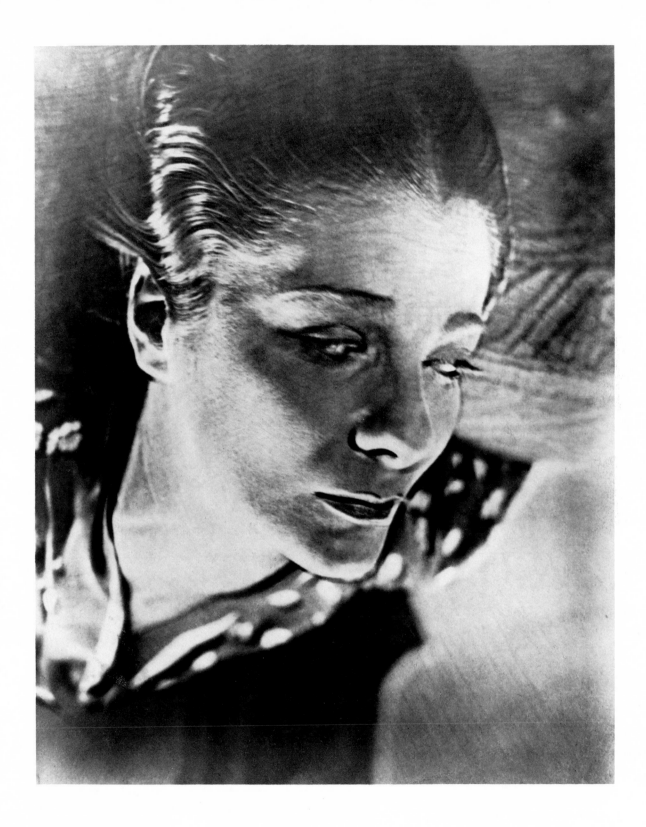

101 Rosalinde Fuller, c. 1936–40

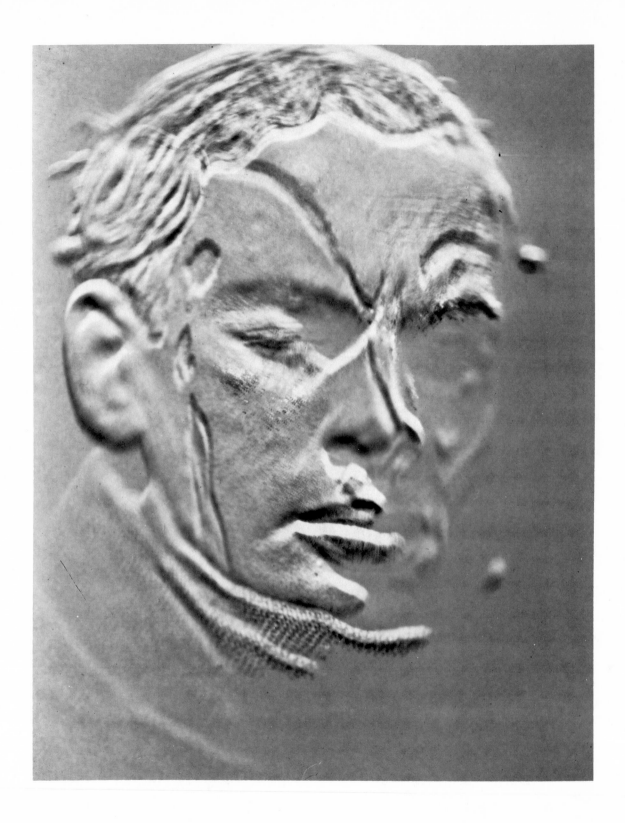

102 Bas-relief and solarized head, c. 1936–40

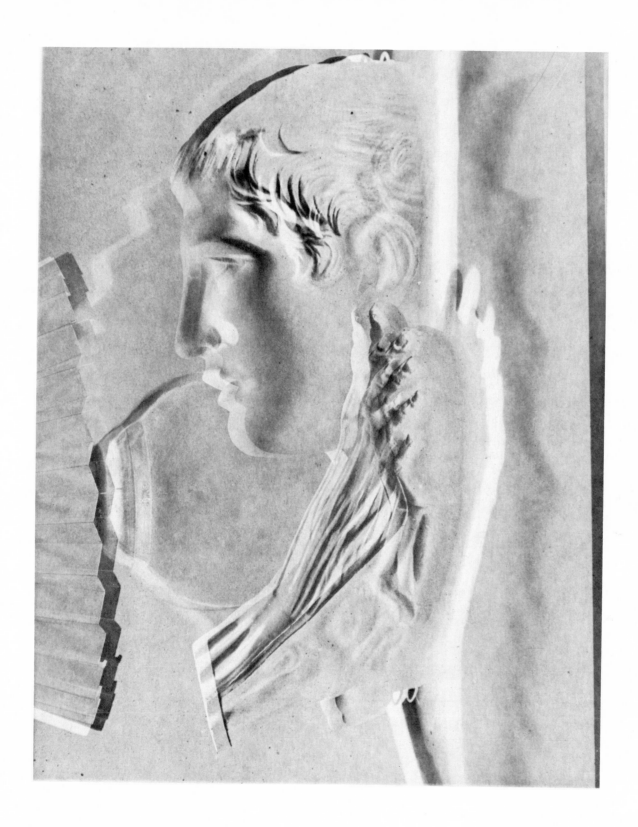

103 Bas-relief print, c. 1936–40

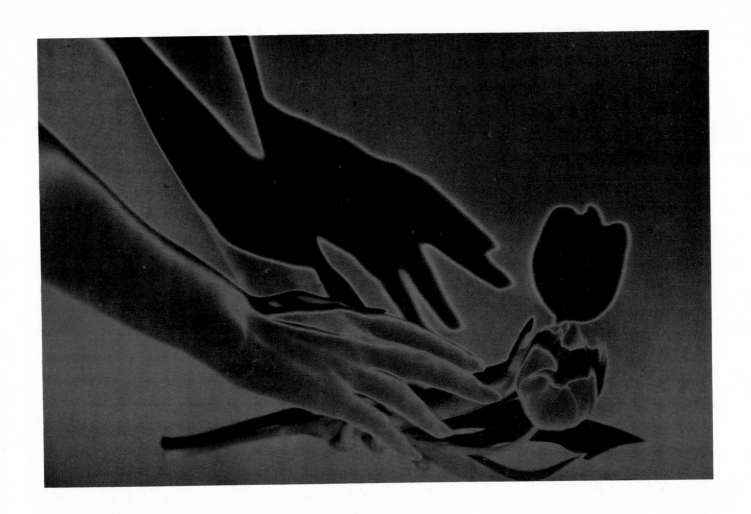

104 and 105 Solarizations, c. 1936–40

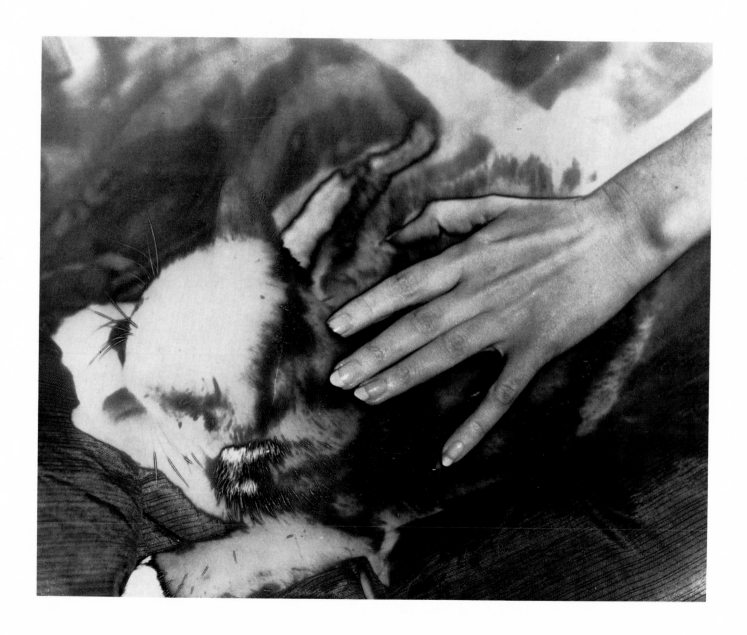

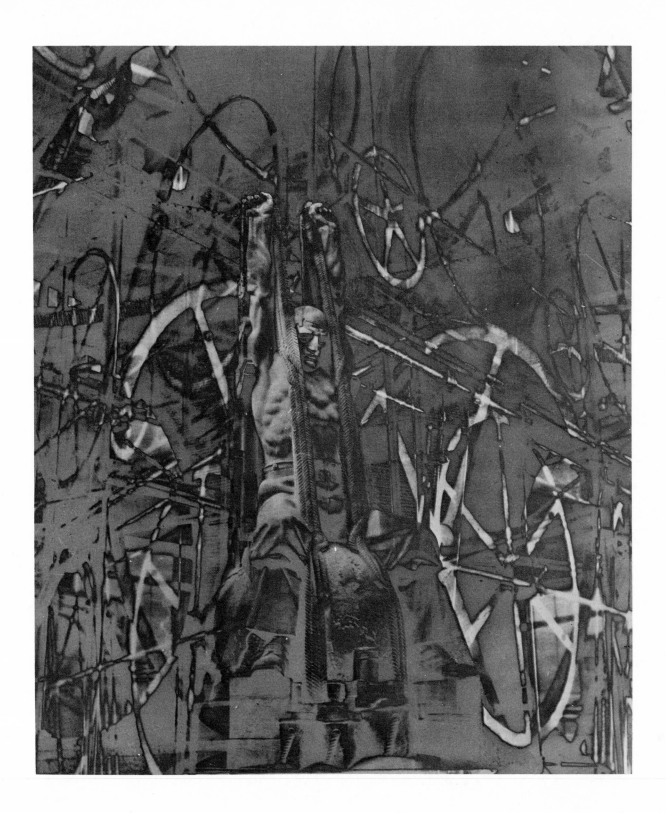

106 Paris Exposition, 1937

process and used paint on glass to make the negative (Plates 107–108). Here, as in other works from the same period, the compositions are similar to the construction of his earlier multiple exposures: individual free-floating shapes merge and overlap, confirming his preference for pattern over line. The character of the forms in these images is also reminiscent of his early Synchromist-inspired paintings. Those shapes in turn belong to his light abstractions. As cameraless abstract works, the paint-on-glass abstractions radiate that ubiquitous quality of light characteristic of most of Bruguière's works. Black textured shapes are surrounded by stark white auras which give the abstraction a sense of depth and substance.

Among his experiments during the thirties, Bruguière seemed curiously drawn to repeating the motifs of his light abstractions. However, what appears to be forms created by light is in fact blurred motion. In these experiments he investigated the possibilities of creating abstract forms from the intrinsic qualities of movement—to investigate, as it were, time rather than space (Plates 109–110). The similarity of these images to his early abstractions, particularly those made without cut paper, rests primarily on the metamorphic quality of the forms. Patient inspection reveals a sense of volume and texture not evident in the first light experiments, an illusion created by the movement of solid objects rather than by transient light. While remaining totally abstract, these new images have qualities that can be associated with the photographs of Bragaglia and Marey.

Bragaglia's "photodynamics" (his own term, referring to the dynamics of motion in the Futurist movement) of 1911–1913 were definite attempts to apprehend in photographs the Futurist ideal. Marey's "chronophotographs" (the name given to his photographs that recorded all phases of motion on a single plate) from the eighties inspired the Futurists and, perhaps, Bragaglia.[66] Through different technical means both photographers pioneered a photographic expression which avoided what Bragaglia called "obscene, brutal, and static realism."[67] In both men's work the transition of time, from one second to the next, was recorded as a physical reality; what had been the sole domain of space was invaded by the mind's ability to supersede the eye. Time was shown to contain volume, texture, and form.

While there is no evidence proving Bruguière's interest in Futurism, his photographs from 1920 on contain visual similarities to the movement's space/time concepts. Bragaglia had given form and volume

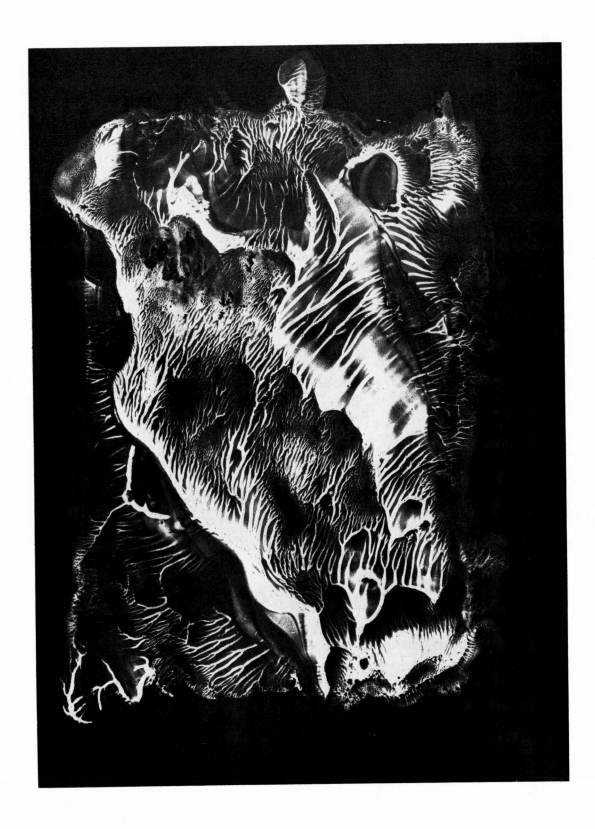

107 and 108 Cameraless abstractions, c. 1936–40

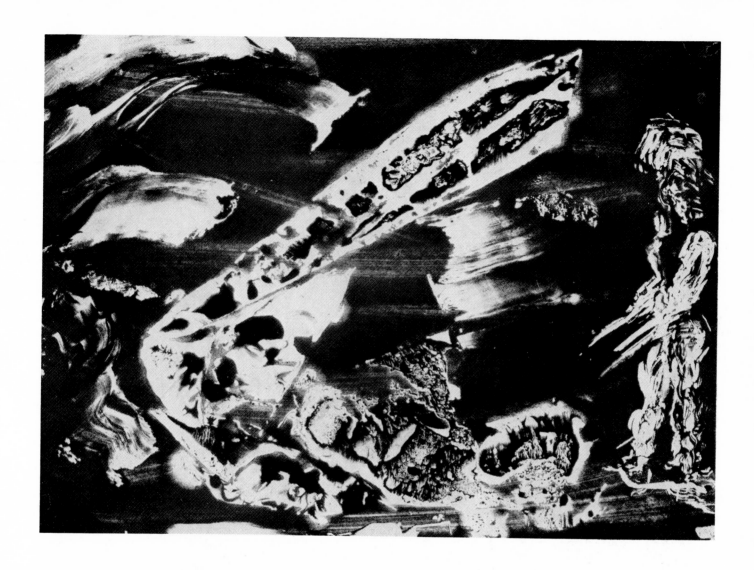

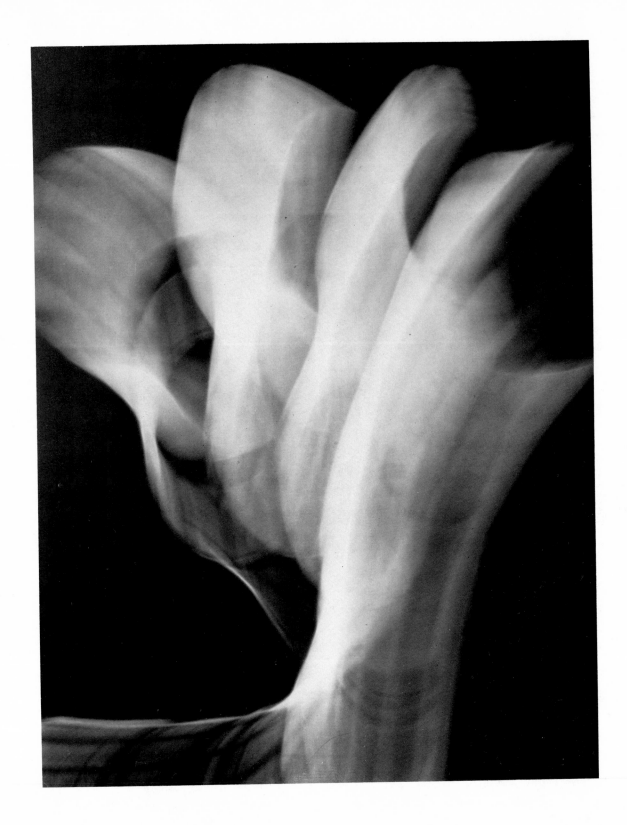

109 and 110 Abstractions, c. 1929

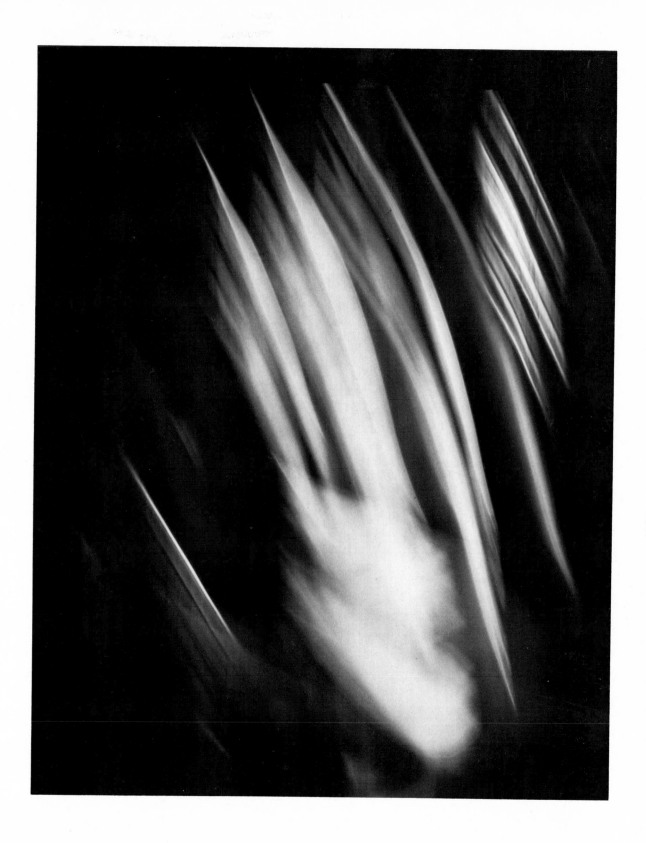

to motion (time), normally imperceptible to the eye. In his photographs space and time were one; time, like space, contained volume and form.

Bruguière's photographs gave substance to man's psyche, which was no less than to give it to time. Both Bruguière's and Bragaglia's photographs were abstract visualizations of cognitive concepts.

Because of Bruguière's self-imposed seclusion from art and society, it is difficult to draw conclusive lines of influence that his work may have had on other photographers. There are, however, a number of interesting parallels among his peers and photographers today.

Edward Steichen's career as a Photo-Secessionist, commercial photographer, and experimentalist matches closely that of Bruguière. Both men were responsible for creative innovations in the commercial world of theatre, fashion, and film. In fact, Steichen's 1931 photograph of Fredric March and Miriam Hopkins in the film *Dr. Jekyll and Mr. Hyde* uses multiple exposure in a way that was indistinguishable from Bruguière's methods.

More contemporarily, the life and work of Wynn Bullock had many extraordinary similarities to those of Bruguière. Bullock experimented with multiple exposure, solarization, cliché-verre, and during the 1940s created a series of what he called "light abstractions." These images, although compositionally distinct from Bruguière's, are in technique and concept exact complements to Bruguière's first light abstractions from the twenties. Bullock also developed a theory of opposites in relation to his beliefs regarding space/time.[68] Just as Bruguière drew support for his ideas from Jung and Taoist writings, Bullock found reinforcement in the works of Alfred Korzybski, a semanticist who wrote on the relatedness of all things in the universe.

Frederick Sommer represents another intriguing parallel to Bruguière. Sommer, like Bruguière, was afflicted with tuberculosis and changed his career. He came to photography through a form of painting (landscape architecture). His photographs cover the same technical range as those of Bruguière and Bullock, involving "straight," handmade negative processes, and cut-paper abstractions. Sommer's cut-paper abstractions, made in the 1960s, are more clearly photographs of cut-paper designs and forms, relying upon his extraordinary drawing ability, than were Bruguière's, which generally used the shaped paper only as a tangential influence on building form with light. Sommer's own words reveal an attitude toward art that is dramatically akin to Bruguière's:

What difference is there between what you find and what you make? You have to make it to find it. You have to find it to make it. You only find things that you already have in your mind.[69]

The abstract qualities of the mind, the psyche, are the primary concerns of Bruguière's and Sommer's work. Light, an entity in itself, is the means through which they interpret those abstract qualities.

Henry Holmes Smith is the only photographer today who has given unqualified credit to Bruguière as a direct influence on his own work:

> The first pictures I saw that made me want to work in this way were those of Francis Bruguière published in Theatre Arts Monthly more than forty years ago.[70]

Like Bruguière, Smith explores the use of light in creating abstract symbols for his memories, emotions, and imagination. He produces his negatives by a variety of handmade means, but predominantly by pouring corn syrup on a sheet of plastic, glass, or film. He then uses a 100-watt spotlight to make the exposure. In addition, technology has made it possible for Smith to render his images in color, a dimension which would most certainly have intrigued Bruguière had it been available in his time.

The work of each of these photographers (Bruguière, Bullock, Smith, Sommer, and Steichen) is the result of a common stratum of influences and interests, regardless of time and place. Several of these men were either painters or had studied painting before taking up photography; each had shown an interest in, if not an attachment to, surrealism; all were inveterate experimentalists and were guided by a personal philosophy that advocated the universality of inner awareness, whether hidden in man's psyche or in nature.

5

Mandalaism

Bruguière had always been an extensive reader and it is apparent from his notes, his unfinished autobiography, and inscriptions written in the front of some of his books shortly before his death[71] that he may have recognized an intriguing relationship between his photographic work and the symbolism of an ancient Chinese Yoga system—the mandala. In addition, C. G. Jung's theories on the psychology of religion and the mandala symbol paralleled the basic elements of Bruguière's philosophy and light images.

It is possible to see from the few pages of Bruguière's unfinished autobiography the roots of his religious and philosophical beliefs. His own confused baptism, mentioned earlier, fixed firmly in his mind the unresolved question of the relationship between the mysteries of man's psyche and a deity.

Bruguière was perplexed by his parents' obsession with social status and ancestry (his father worried about the annual painting of their

house and saw it as a reflection of one's respectability and "being worthy of the neighborhood").

In his autobiography Bruguière described a childhood experience that emphasized the inhumanity of certain traditions:

> It was with him [a childhood friend], my brother Emile and a couple of other boys that we went to Chinatown and saw what I did not then realize was a slave girl. We scraped up, between us, enough money to satisfy her Chinese Kupu; passing by several doors and narrow halls which were partitioned off by dark and dirty boards, we stopped before a door which the Chinaman lighted by a single gas jet. The air stunk as we were below the street level. How human beings could live in such a place!
>
> The slave girl, naked, hairless, with small round breasts, tall enough to almost reach the ceiling was standing on a wooden bed about three feet above the floor. Her black hair brushed straight back and tied in a bun knot. Her eyes looked at us, expressionless, as was her face. She was entirely detached. Perhaps there were hidden springs which needed something besides the curiosity which was the only quality we brought. But it is difficult to imagine that these un-wanted Chinese girl children, of whom so many were brought to San Francisco, could have been anything but sacrificial victims to a kind of perverted lust that we may still have; but which, thru our Christian Civilization has turned into love for our fellow human beings instead of the desire to enslave them. Nevertheless there is prostitution and procuring widely practiced. It may be largely due to economic classes, but there is always the desire of man to assert his superiority over woman, to keep her in a subordinated and de-pendent position thereby building himself towards a perpetuation of himself, to a kind of created Godhood.[72]

Bruguière became an agnostic who was repelled by social super-ficialities, yet remained sensitive to life's contrasts. Inspired by his agnostic views, he found an interest in the mandala beyond its visual correlation to his work. The mandala revealed the essence of the Taoist scripture, which for Bruguière offered a cognitive alternative to tradi-tional religion. Where Bruguière had sought inner peace through his work, the Taoist scripture offered divine peace through inner aware-ness. In the front of his favorite book, *The Secret of the Golden Flower*, he wrote the following quote from Jung's *Psychology of Religion:*

A modern mandala is an involuntary confession of peculiar mental condition. There is no deity in the mandala and there is also no submission or reconciliation to a deity. The peace of the deity seems to be taken by the wholeness of man.

Bruguière spent his entire life attempting to resolve, through his work, the meaning of his deepest emotions. It must have been quite a triumph for his spirit to find an age-old system of thought that so closely paralleled his own.

The Secret of the Golden Flower is a Taoist-Yoga system for meditation written in the eighth century. The edition translated by Richard Wilhelm includes an analytical commentary by Jung, which seems to have meant more to Bruguière than the text itself. The book and Jung's interpretation also contain tempting terminological coincidences with the vocabulary of Bruguière's imagery: "Light is the symbolic equivalent of consciousness and the nature of consciousness is expressed by analogies with light."[73] "Tao [the goal of meditation] is the meaning—the way."[74] "Circulation of the light is not only a circulation of the seed-blossom of the one body, but it is, in the first place, a circulation of the true, creative, formative powers."[75]

The historical occurrence of the mandala or its parallel symbolism has been shown by Jung to belong to the most primordial of civilizations and continues to occur in contemporary society. Most of the examples identified by him are in some way linked to the most creative (i.e., artistic) elements of a given culture:

> When the fantasies are chiefly expressed in thoughts, the results are intuitive formulations of the dimly felt laws or principles, and these tend to be dramatized or personified. If the fantasies are drawn, there appear symbols that are chiefly of the so-called mandala type. Mandala means circle, more especially a magic circle, and this form of symbol is not only to be found all through the East but among us; mandalas are amply represented in the Middle Ages. The specifically Christian ones come from the earlier Middle Ages. Most of them show Christ in the centre, with the four evangelists or their symbols at the cardinal points. This conception must be a very ancient one because Horus was represented with his four sons in the same way by the Egyptians.[76]

Although Jung and other authors have often found a distinct tendency toward symmetry and four parts at the base of a mandala, there is

a definite irregularity in the proportions, scale, and subtlety of the mandala parts.[77] In the identification of a mandala, equal importance is given to the emanation of the parts from a center or central point. In regard to Bruguière's work, an identifiable characteristic of the mandala is his centrally emanating abstract compositions, as in Plate 111. Jung suggests that the inspiration for such creations may stem, in part, from psychological sources common to the unconscious, regardless of time or culture (Plates 111–112).

In *The Secret of the Golden Flower*, illustrated by a series of European mandalas (Jung's patients), Jung analyzes the sources for this strange commonality. He unveils the potential for new ideas, concerning not just Bruguière's light abstractions, but much of modern art as well:

> . . . just as the human body shows a common anatomy over and above all racial differences, so too does the psyche possess a common substratum. I called the latter the collective unconscious.[78] Taken purely psychologically, it means that we have common instincts of ideation (imagination) and of action. All conscious imagination and action have grown out of the unconscious prototypes, and remain bound up with them. . . .[79]
>
> When my patients produce these mandala pictures it is, of course, not through suggestion. . . . The pictures came quite spontaneously and from two sources. One source is the unconscious, which spontaneously produces such fantasies; the other source is life, which, if lived with complete devotion brings an intuition of the self, the individual being. . . .[80]
>
> The unconscious can only be reached and expressed by the symbol, which is the reason why the process of individuation can never do without the symbol. The symbol is, on the one hand, the primitive expression of the unconscious, while, on the other hand, it is an idea corresponding to the highest intuition produced by consciousness. . . .[81]
>
> It is therefore more probable that we are dealing with an a priori "type," an archetype which is inherent in the collective unconscious and thus beyond individual birth and death. The archetype is, so to speak, an "eternal" presence, and it is only a question of whether it is perceived by consciousness or not.[82]

The mandala form has been found to exist in the Aztec sun stone, the rose window of Chartres, Stonehenge, Navajo sand painting, and a

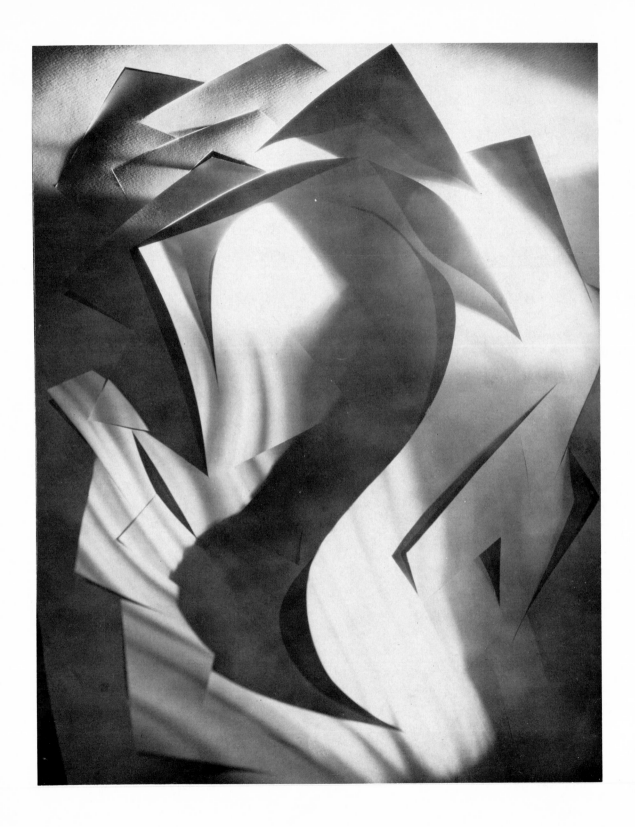

111 From *Beyond This Point,* 1929

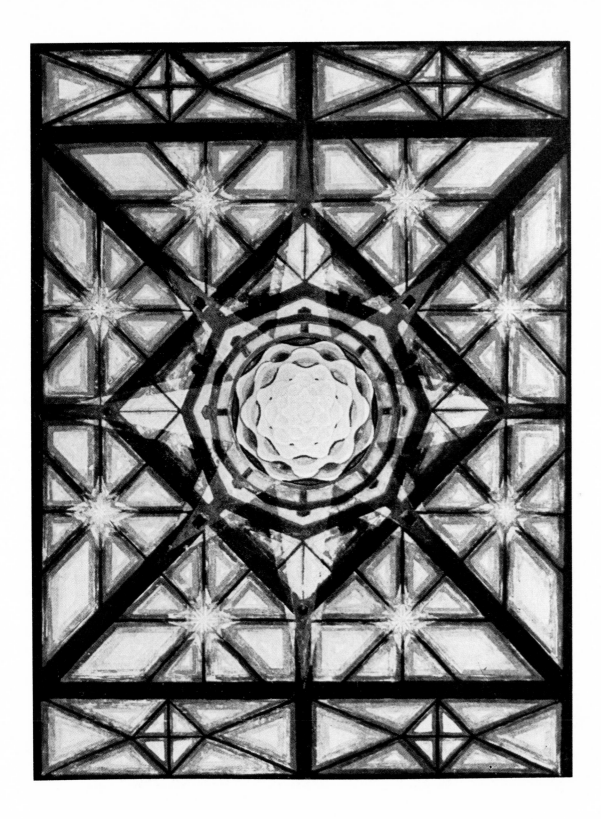

112 Mandala by one of C. G. Jung's patients

vast array of natural microscopic and astronomical elements of the universe. Bruguière's photographs do not relate to these and other mandalas as perfect analogies. The complex influences of other art forms and his own sense of visual satisfaction controlled and changed any "automatic" result. His association with the mandala is, rather, in the spirit of the sources for it, his recognition of it, and his preoccupation with the abstract qualities of that spirit.

Bruguière's recognition of the similarity between his work and the mandala or "self," as Jung interprets it, has precedents in both art and technology. On a scientific level, Kirlian photography (cameraless, high-voltage photography) has been able to record invisible evidence of "life" in any living organism as electroenergy emanations or "aura." It is possible, therefore, to photograph the *essence* of the human body unrelated to our conscious perception of it, and, curiously enough, the images formed by the process appear as patterned shapes similar to other natural mandalas. From an aesthetic point of view, Abbot Suger of Saint-Denis (1081–1151, minister and adviser of Louis VI and Louis VII of France) referred to the "analogical" function of stained-glass windows, which he introduced into church architecture in the twelfth century. According to José and Miriam Arguelles in *Mandala*, a study of its history and symbolism, Suger meant by analogical, "that which leads the senses through contemplation to a state beyond the senses."[83] Stieglitz's equivalents and Bruguière's light abstractions aspired to this same ideal.

The edition of *The Secret of the Golden Flower* in Bruguière's library was published in 1942, which means he had acquired it shortly before his death, in 1945. In 1944 he had begun his autobiography. Between 1940 and 1945, when he was no longer making photographs, Bruguière had turned his attention to an assessment of his life and work.

If one takes a selection of passages from Jung's analysis of *The Secret of the Golden Flower*, as Bruguière might have done, it is possible to perceive the nature and extent of his affinity for the book. For example, in discussing the collective unconscious and analyzing the relationship of the Taoist "way" to Western man, Jung reminds his readers:

> We are so greatly tempted to turn everything into purpose and method that I deliberately express myself in very abstract terms in order to avoid causing a prejudice in one direction or another.[84]

Jung's statement was, of course, a literalization of what Bruguière had practiced throughout his life's work. In addition, it echoed an un-

derstatement made by Bruguière in an address to the Pictorial Photographers of America in 1927: no literal meaning should be read into his abstractions, he said, any more than into a Bach fugue.[85]

Francis Bruguière wrote:

A photograph has been said to look "just like nature," but no one has ever agreed just how nature looks; it may, therefore, be questioned whether a photograph really looks anything like nature. . . . A photograph can be something in itself—it can exist independently as a photograph apart from the subject; it can take on a life of its own.[86]

Francis Bruguière died, of complications suffered from a cold, in May 1945, on the day that peace was declared in Europe.

Notes

1. The description of Bruguière's attitude is based on taped interviews, by the author, with Oswell Blakeston (friend, writer, and film critic) and with Rosalinde Fuller (Broadway actress, who lived with Bruguière for twenty-five years).
2. *Art News and Review*, vol. 1, no. 8 (May 21, 1949).
3. *Camera Work*, no. 39 (July 1912), "The Sun Has Set," p. 17.
4. Ibid., no. 5 (January 1904), p. 21.
5. Ibid., no. 30 (April 1910).
6. In a letter from Bruguière to Sadakichi Hartmann, dated September 24, 1923, New York, Bruguière wrote the following: "Things go about the same way out here, I never see painters and photographers. Better luck for me."

From the Wistaria Hartmann Linton Collection, University of California, Riverside.

7. Although various publications have recorded Bruguière's birthdate as 1880, the date is incorrect. In a letter, dated January 22, 1938, from Bruguière's son to his father is the following: ". . . of course there's a little silver mug that my baby drinks out of that's dated October 16, 1879—and that mug was your mug and you used to drink out of it yourself." Even Bruguière's closest friends were never sure of his birth date. In letters to Bruguière, Frank Eugene would periodically repeat his question: "Lieber Bruder, . . . How old are you?" (It seemed to be a common practice among Bruguière's friends

to address him in affectionate terms: Sadakichi Hartmann referred to him as "Dear Prince" and Oswell Blakeston called him "Dear Holy Man" in letters.)

8. Bruguière was proficient in at least two instruments, the piano and the banjo. He wrote one known piano composition, for Rosalinde Fuller, and in a letter from Eugene, dated March 3, 1933, was the following: "Have you a banjo? Francis and do you sometimes play that delightful old song 'On Board the Robert E. Lee'?"

9. Eugene was Bruguière's elder by thirteen years. When Eugene was sixty-nine years old, he was hospitalized for six months in Munich. The correspondence between Bruguière and Eugene during this time reveals a brotherly relationship in which Bruguière kept Eugene supplied with fresh reading material and regular correspondence to dispel the agony of being bedridden.

10. *Art in America*, no. 3 (1959), p. 58.

11. From a letter by Eugene to Bruguière dated May 12, 1936: ". . . yes! When I think of the never-ending struggle our dear friend Robert Loftin Newman had trying to make 'both ends meet' . . . and A. P. Ryder too, with the surprisingly large heap of clear ashes in front of his hearth—and the canvases over which he now and then poured pure varnish—they were both big men! Admirable and lovely in every way." It should also be noted that both Eugene and Bruguière were painting as well as making photographs during the time to which the letter refers (c. 1905–1906).

12. *Camera Work*, no. 47 (January 1915), p. 29. Article dated July 1914.

13. Ibid., no. 48 (October 1916), "Our Illustrations," p. 62.

14. Ibid., no. 33 (1911). The exhibition included 584 prints. Bruguière's work was included in the third section, prints by previously unexhibited Americans who submitted them to Stieglitz. There was also a section of prints selected by the Photo-Secession and a European section.

15. Ibid. Stieglitz sent Bruguière a copy of this issue of *Camera Work* with a note written on the paper stock used for the publication: "Finally—It has been a long time coming. But it has come. —Here it is. —I hope it will give you pleasure. —With greetings, Stieglitz."

16. Exhibition catalogue, "Photographs and Paintings by Francis Bruguière," The Art Center, New York, March 28–April 11, 1927. Arranged by the Pictorial Photographers of America.

17. "291—A New Publication," *Camera Work*, no. 48 (October 1916), p. 62.

18. *Picture Post*, vol. 43, no. 7 (May 14, 1949), pp. 31–33.

19. *Modern Photography Annual*, 1935–1936, p. 13.

20. *Art in America*, no. 3 (1959), p. 59.

21. John Mason Brown, *Boston Evening Transcript*, April 9, 1927.

22. Lee Simonson in "Photographs and Paintings by Francis Bruguière," March 28–April 11, 1927: "His photographs are more than records—they are interpretation and criticism. What he has seen thru his camera's eye in modern theatre is what is most worth remembering, because he has seen it."

23. Francis Bruguière, "The Camera and the Scene," March 1924, in *Theatre Arts Anthology*, edited by Rosamond Gilder, Hermine Rich Isaacs, Robert M. MacGregor, and Edward Reed (Theatre Arts Books, 1950), pp. 400–402.

24. Quoted by John Mason Brown in *Boston Evening Transcript*, April 9, 1927.

25. Exhibition catalogue, "Surrealisme," Wadsworth Atheneum, Fall 1931; later shown at the Julien Levy Gallery in New York City, 1932. (The author is gratefully indebted to Anne Tucker for this note.)

26. Contents of exhibition: 5 portraits of Margaret Petit, 5 portraits of Angna Enters, 5 portraits of Rosalinde Fuller, 5 stage sets by Lee Simonson, 5 stage sets by Robert Edmond Jones, 5 stage

sets by Norman Bel Geddes, 29 Designs in Abstract Forms of Light, 35 photographs from *The Way*, 6 watercolors, 4 paintings.

27. *The New York Times*, April 3, 1927.

28. *Boston Evening Transcript*, April 9, 1927.

29. See David Curtis, *Experimental Cinema* (London: Studio Vista, 1971).

30. See Lotte H. Eisner, *The Haunted Screen* (London: Thames and Hudson, 1969).

31. Aaron Scharf, *Creative Photography* (London: Studio Vista, 1965), p. 35.

32. In Lucy Lippard, ed., *Surrealists on Art* (Prentice-Hall, 1970), p. 10.

33. Ibid., p. 13.

34. Walter Kaufmann, *Nietzsche—Philosopher, Psychologist, Antichrist* (World Publishing, Meridian Books, 1966), pp. 155–56.

35. The announcement for the memorial exhibition of Bruguière's work at the Focal Press in London, May 1949, mentions that following the production of the photographs for *The Way*, Bruguière received commissions to make trick sequences for Hollywood films, although the films are not named. In addition, it was reported in *What's On in London*, vol. 12, no. 702, p. 11, and the *Glasgow Herald*, April 30, 1949, that these photographs were exhibited at the pre-Hitler Reichstag and as a result a bill was passed giving photography the status of art, which it had not had before then.

The sets and backdrops for the photographs of *The Way* were by Jonell Jorgulessco, a young New York artist (from an original draft of an article by Sebastian Droste for *Die Dame*, June 1925).

36. Exhibition brochure, "Photo Eye of the '20's," Museum of Modern Art, New York, 1970.

37. Barbara Rose, *American Art Since 1900* (Praeger, 1967), p. 92.

38. *The New York Times*, April 3, 1927.

39. Nathan Lyons, ed., *Photographers on Photography* (George Eastman House,

1971), p. 35; from an article by Bruguière for *Modern Photography Annual*, 1935–1936: "In making subjects of my own I have used paper-cut designs brought into low relief, and lit, generally, by one small spot lamp of 250 watts; the same lamp has been placed in different positions through a series of exposures."

40. Stark Young, Edith J. R. Isaacs, and Kenneth Macgowan, eds., *Theatre Arts*, vol. VI, no. 1 (January 1922), pp. 23–26; Bruguière's photographs of stage sets also appear in the magazine, on pp. 11, 42–45.

41. Ibid., p. 29.

42. Ibid., pp. 21–22.

43. *Art in America*, no. 3 (1959), p. 58.

44. H. A. Potamkin, "New Ideas for Animation," in *Movie Makers*, December 1929.

45. *Art in America*, no. 3 (1959), p. 59.

46. Ibid.

47. From a letter by Francis Bruguière, Jr., to his father, September 18, c. 1940: "By the way I went to a camera club lecture and who should speak but a fellow by the name of Moholy-Nagy or something. Anyway he talked about abstractionism etc. and showed a lot of lantern slides. . . . Moholy what's his name talked about you for a few minutes."

48. Mark Haworth-Booth, "E. McKnight Kauffer," *Penrose Annual* (London, 1971), p. 83.

49. Mention is made of these two photographers in order to provide the reader with an idea of the latitude of the work in the exhibition. Steichen's entries included fashion photographs from *Vogue* and Heartfield was represented by his graphic satirical montages.

50. Hartmann was evidently quite forward in his personality and letters, so that this criticism of Bruguière's photographs —dated "last day of the year, 1931"— was probably received with a smile. However, Bruguière's response is difficult to assess accurately: "I'm glad you like some of the photo designs in

the book & I agree with you about the human part which I never wanted in. I don't like faces in photography & the only use I can see that they have is for friends, but they are a bore till the clothes become 'costumes' & then they have a kind of . . . interest. The writing of the book is terrible & you are right, its the author's face on the cover" (February 18, 1932, from the Wistaria Hartmann Linton Collection, University of California, Riverside).

During this time (the Depression), Hartmann was having extreme financial difficulties, was depressed, and needed encouragement. Bruguière, as a lifelong friend of Hartmann's and a compassionate man, may have told the "critic" what he wanted to hear. Regardless of what Bruguière said in this letter, he continued to exhibit the photographs from the book, including those with faces, and in fact, had a great deal of control over what went into the book and the choice of authors. The book was published entirely at Bruguière's expense.

Bruguière's comment on the writing of the book as "terrible" would, in light of a compassionate motive, be a further attempt to raise the spirits of Hartmann, who apparently considered himself the greatest writer of all time. For example, in another letter Hartmann appealed to Bruguière to "send me a pound or two that I can write more poetry." And in an earlier letter (February 14, 1929, Wistaria Hartmann Linton Collection), which apparently had the same request, Bruguière answered: "Dear Kichi: It is a pity that I shall not have the distinction of being mentioned among those who did not 'cough up.' Perhaps I am missing a passport to immortality! Who knows?" He closed his letter to Hartmann with: "Be not too virtuous for in the belly of time all things are digested."

Hartmann's acid criticism was, however, often revealing, as in letters dated March 3, 1929, and December 31, 1930, in which he wrote: "Stieglitz makes me super tired . . . he has turned into an Omar and has burnt (?) all remaining copies of Camera Work." Bruguière responded in a letter dated December 12, 1931 (Wistaria Hartmann Linton Collection): "I hear nothing about Stieglitz . . . tho the destroying of Camera Work can only add to the value of the few sets that were not destroyed."

Bruguière's and Hartmann's correspondence reveals a combination of honest exchange about photography and rhetoric devoted to the support of a friend's (Hartmann's) eccentric but fragile egotism.

51. The catalogue for the Warren Gallery exhibition contained the following note: "Mr. Bruguière's photographs are published in limited editions of six prints only."
52. Jack Ellit also edited the music for Len Lye's extraordinary film *Trade Tattoo*, made in 1936 for the British Postal Service.
53. Both films of *Light Rhythms* were found by Rosalinde Fuller in February 1975, among early portfolios of Bruguière's drawings and paintings.
54. *Architectural Review*, vol. 67 (March 1930), pp. 154–55.
55. Exhibition brochure, "E. McKnight Kauffer: Poster Art 1915–1940," Victoria and Albert Museum, September 1973, introd. by Mark Haworth-Booth.
56. Ibid.
57. Ibid.
58. *Commercial Art and Industry*, vol. 21 (1934), p. 53.
59. Oswell Blakeston, "The Architect at the Movies," *Architectural Review*, vol. 75 (1934), p. 21.
60. Illustrated in *New York in the Thirties* (Dover, 1973).
61. "Pseudomorphic Film by Oswell Blakeston," *Close Up*, 10:1 (1933), pp. 19–20.
62. *Modern Photography Annual*, 1935–1936, p. 9.
63. Middleton Cheney, where Bruguière is

buried, is a small village near Oxford. In a nearby park Rosalinde Fuller gave, as a memorial to Bruguière, a slide for the village children. At the bottom of the slide is a plaque which reads: "This is a present to the children of Middleton Cheney from their friend, Francis Bruguière of San Francisco."

64. *Modern Photography Annual,* 1935–1936, p. 11.

65. *Photographers on Photography,* p. 33.

66. Aaron Scharf, *Art and Photography* (London: Penguin, 1968), pp. 199–208.

67. Ibid., p. 207.

68. Barbara Bullock-Wilson, *Wynn Bullock* (Morgan and Morgan, 1973), p. 24.

69. Frederick Sommer exhibition catalogue, by Gerald Nordland, Philadelphia College of Art, November 1968, p. 9.

70. In a letter to the author, Henry Holmes Smith expanded on the relationship between his "light refraction drawings with syrup and water" and the light abstractions of Bruguière. "His [Bruguière's] work was primarily responsible for my introducing light modulator exercises in the first photography course at the New Bauhaus in October 1937 with Moholy-Nagy's enthusiastic support.

"In my own work it took me an incredible span of time, 1931–48, to figure out what to do with that nudge from Bruguière's work. Finally, after the second world war it dawned on me how to use it for myself."

71. A note concerning Jung's *Psychology of Religion* was written by Bruguière in his favorite book, *The Secret of the Golden Flower,* trans. by Richard Wilhelm, with a commentary by C. G. Jung (London: Kegan Paul, Trench, Trubner, 1942), pp. 77–93.

72. Bruguière's unfinished autobiography, pp. 1–3. Bruguière's autobiography was started on April 17, 1944. It covers only his early childhood.

73. *The Secret of the Golden Flower,* p. 95.

74. Ibid., p. 94.

75. Ibid., p. 35.

76. Ibid., p. 97.

77. José and Miriam Arguelles, *Mandala* (Berkeley, Calif., and London: Shambala, 1972).

78. *The Secret of the Golden Flower,* p. 83.

79. Ibid., p. 84.

80. Ibid., p. 99.

81. Ibid., p. 105.

82. "The Symbolism of the Mandala," *The Collected Works of C. G. Jung,* p. 211.

83. *Mandala,* p. 44.

84. *The Secret of the Golden Flower,* p. 89.

85. "National Alliance of Art and Industry," *Art Center Bulletin,* vol. 5 (March 1927), p. 126.

86. *Photographers on Photography,* pp. 33–34.

Chronology

1879–1900 Francis Bruguière born in San Francisco October 16, 1879. Grew up in San Francisco, studied in boarding school in eastern U.S., and toured Europe, gaining appreciation for music, painting, and poetry.

1901–1904 Married actress from North Carolina in 1901. Francis Bruguière, Jr., born in 1904. Began to search for means to express himself in visual terms.

1905 Visited New York and began to study photography with Frank Eugene. Met Stieglitz and became member of Photo-Secession.

1906–1909 Following great earthquake and fire, remained in San Francisco. Continued to paint but became regular practitioner of photography, making portraits and soft-focus images. Opened studio on Franklin Street.

1910–1918 Four photographs included in International Photo-Secession Exhibition at Albright-Knox Art Gallery in Buffalo, New York. Wrote "What *291* Means to Me" for publication in *Camera Work*. In 1916, photograph published in *Camera Work*. Toured Europe and Greece in 1912–1913. Began experiments with multiple exposure, 1912. Published *San Francisco*, 1918.

1919–1922 Forced to rely on photography as primary source of income and moved to New

York. Set up free-lance studio and continued experiments. Began work for *Harper's Bazaar, Vogue, Vanity Fair,* and the Theatre Guild. Photographed Wilfred's color organ projections and met Rosalinde Fuller. Developed close and lasting friendships with Sadakichi Hartmann and Baron de Meyer.

1923–1927 Met Sebastian Droste and began series of photographs for *The Way,* but left project unfinished when Droste died. Began experiments with light and cut paper. First major one-man exhibition at Art Center in New York. Visited London with Rosalinde Fuller.

1928–1929 Moved to London with Rosalinde Fuller. One-man exhibition at Der Sturm Galleries in Berlin. Became honorary member of German Secession. Interviewed by Oswell Blakeston, with whom he became close friend and artistic collaborator. Invited to exhibit at Deutsche Werkbund exhibition, "Film und Foto." Published *Beyond This Point* with Lance Sieveking. One-man exhibition at the Warren Gallery, London.

1930–1932 Made Britain's first abstract film, *Light Rhythms,* in cooperation with Oswell Blakeston. Made series of "straight" and abstract multiple exposures of England's cathedrals. Second one-man exhibition at the Warren Gallery. Returned to New York for visit and created series of photographs on New York architecture for "pseudomorphic film." Published *Few Are Chosen* in cooperation with Oswell Blakeston.

1933–1937 Met E. McKnight Kauffer and collaborated on advertisements and new photographic experiments. Joint exhibition with Kauffer at Lund, Humphries Galleries, London. Began new series of images based on experimentation as an end in itself. Became official designer for gateway to British Pavilion at the 1937 Paris Exposition.

1940–1945 Moved to small village of Middleton Cheney to return to painting. Health became fragile and he returned to London. Began autobiography and to reinvestigate work of C. G. Jung and the mandala. Died in May 1945, on the day peace was declared in Europe, and was buried in Middleton Cheney.

Selected
Bibliography

BOOKS

BEATON, CECIL, and BUCKLAND, GAIL. *The Magic Image*. Boston: Little, Brown, 1975.

BRUGUIÈRE, FRANCIS. *San Francisco*. San Francisco: H. S. Crocker Co., 1918.

BRUGUIÈRE, FRANCIS, and BLAKESTON, OSWELL. *Few Are Chosen*. London: Eric Partridge Ltd., 1932.

DOTY, ROBERT. *Photography in America*. London: Thames and Hudson, 1974.

FRAPRIE, FRANK R., and WOODBURY, WALTER E. *Photographic Amusements*. Boston: American Publishing Co., 1931.

GEDDES, NORMAN BEL. *Horizons*. Boston: Little, Brown, 1932.

LYONS, NATHAN, ed. *Photographers on Photography*. Rochester, N.Y.: George Eastman House, 1971.

ROTZLER, W. *Photographie als Kunstleriches Experiment*. Lucerne, Switzerland: Bucher, 1974.

SHAWN, TED. *Ruth St. Denis, Being a History of Her Cycle of Oriental Dances*. San Francisco: John Nash, 1920.

STONE, JOHN. *Creative Art in England*. London: Stanley Nott, 1936.

PERIODICALS

Architectural Review, vol. 70–100 (July–December 1931), illustrations from *Few Are Chosen*.

BEATON, CECIL. "Francis Bruguière," *Art News and Review*, vol. 1, no. 8 (May 21, 1949).

BLAKESTON, OSWELL. "The Architect at the Movies," *Architectural Review*, vol. 75 (1932).

———. "The Cinema in England," *Educational Screen*, May 1931.

———. "The Film and Final Statements," *Architectural Review*, vol. 69 (1931).

———. "Five Minutes with Francis Bruguière," *Close Up*, vol. 4, no. 4 (1929).

———. "Light Rhythms," *Close Up*, vol. 6 (March 1930).

———. "Pseudomorphic Film," *Close Up*, vol. 10, no. 1 (1933).

———. "The Still Camera Today," *Architectural Review*, vol. 71 (1932).

———. "The Works of Francis Bruguière," *Picture Post*, vol. 43, no. 7 (May 1949).

BRUGUIÈRE, FRANCIS. "A Photograph Will and a Photograph Won't," *Advertising Display*, vol. 9, no. 4 (October 1930).

———. "The Camera and the Scene" (March 1924), in MacGregor, Robert, ed., *Theatre Arts Anthology, 1916–1950*.

———. "Professionally Speaking" (a short story), *Close Up*, April–July 1933.

The Bystander (Tatler), May 26, 1937, "Francis Bruguière, Maker of Murals for the British Pavilion at the Paris Exhibition."

CHAPPELL, WALTER. "Francis Bruguière," *Art in America*, vol. 47, no. 3 (1959).

Commercial Art and Industry, vol. 16 (February 1934), "The Work of Kauffer and Bruguière."

Die Dame, January 2, 1927, "Bruguière's Seltsame Photographien."

Film Art, International Review of the Advance-Guard Cinema, no. 3 (Spring 1934).

The Graphic, November 30, 1929, "Mind Photography."

LANDAU, MARGOT. "The Relationship of the Lens to the Brush," *Advertising Display*, January 1928.

The Listener, December 20, 1933, "Photography, Decoration, and Commerce."

MERCURIUS. "Light: The Photography of Francis Bruguière," *Architectural Review*, vol. 67 (January 1930).

———. "Light and Movement," *Architectural Review*, vol. 67 (March 1930).

NOXON, G. F. "Francis Bruguière," *Experiment*, nos. 3, 5, 15, 1928–31, in *Modern Photography Annual, 1935–36* (London).

POTAMKIN, H. A. "Camera Work as an Art Factor," *Film Weekly* (London), December 31, 1928.

———. "Francis Bruguière," *Transition* (Paris), November 1929.

———. "New Ideas for Animation," *Movie Makers* (London), December 1929.

VAN HECKE, P. G. *Variétès*, Revue Mensuelle illustrié de l'esprit contemporain, no. 2 (Brussels: June 15, 1929).

VAN TASSEL, PETER. "Wandlungen de Photographie, Von Daguerre bis Bruguière," *UFA*, September 1926.

What's On in London, vol. 21, no. 702 (April 29, 1949), "Something Unique."

REVIEWS

BROWN, JOHN MASON. "Bruguière as Artist in Lights," *Boston Evening Transcript*, April 9, 1927.

Christian Science Monitor, April 4, 1927.

Glasgow Herald, April 30, 1949, "Photo-Picasso."

New York Times, April 3, 1927, "The Week's Art Notes."

READ, HELEN A. *Brooklyn Eagle*, April 3, 1927.

ST. BERNARD, GUI. *Westminster Gazette,* November 21, 1929, "Picturised Emotions."
————. *Westminster Gazette,* 1931 (specific date not known), "Dizzy Distortions."

EXHIBITION CATALOGUES

The Art Center, New York. March 28–April 11, 1927. *Photographs and Paintings by Francis Bruguière.*

BRINTON, CHRISTIAN. *Impressions of the Art at the Panama-Pacific Exposition.* John Lane Co., 1916.

The Art Institute of Chicago. December 11, 1976–February 20, 1976. *Photographs from the Julien Levy Collection,* p. 35.

Deutsche Werkbund. Stuttgart. May 18–July 7, 1929. *Film und Foto.*

Lund, Humphries Galleries, London. November–December 1933. *Francis Bruguière in Collaboration with E. McKnight Kauffer.*

The Warren Gallery, London. 1929. *Photographic Designs by Francis Bruguière.*

COLLECTIONS

Norman Bel Geddes Collection, Hoblitzelle Theatre Arts Collection. Humanities Research Center, the University of Texas at Austin.

International Museum of Photography at George Eastman House, Rochester, New York.

Julien Levy Collection. Art Institute of Chicago.

Bruguière Collection, Theatre Collection. New York Public Library at Lincoln Center.

Oakland Museum of Art, Oakland, California.

University of Kansas Museum of Art, Lawrence, Kansas.

Numerous private collections.

A Note on the Type

The text of this book was set in Waverley, a typeface produced by the Intertype Corporation. Named for Captain Edward Waverley, the hero of Sir Walter Scott's first novel, it is inspired by the spirit of Scott's literary creation rather than actually being derived from the typography of that period. Indeed, Waverley is a wholly modern typeface, if not by definition, certainly by association with the designs of our best contemporary typographers.

This book was composed by American Book–Stratford Press, Inc., Saddle Brook, New Jersey, and printed and bound by Halliday Lithograph, West Hanover, Massachusetts. Illustration film preparation by Creative Lithography, Inc., New York, New York.

The book was designed by Earl Tidwell